BIG BRATTY BOOK OF BART SIMPSON

Copyright © 2002, 2003 & 2004 by
Bongo Entertainment, Inc. All rights reserved.
No part of this book may be used or reproduced in any manner whatsoever
without written permission except in the case of brief quotations
embodied in critical articles and reviews. For information address:
HarperCollins Publishers Inc.,
10 East 53rd Street, New York, NY 10022.

HarperCollins books may be purchased for educational, business, or sales
promotional use. For information please write:
Special Markets Department,
HarperCollins Publishers Inc.,
10 East 53rd Street, New York, NY 10022.

FIRST EDITION

ISBN 0-06-072178-2

04 05 06 07 08 QWM 10 9 8 7 6 5 4 3 2

Publisher: MATT GROENING
Creative Director: BILL MORRISON
Managing Editor: TERRY DELEGEANE
Director of Operations: ROBERT ZAUGH
Art Director: NATHAN KANE
Production Manager: CHRISTOPHER UNGAR
Legal Guardian: SUSAN A. GRODE

Trade Paperback Concepts and Design: NATHAN KANE

Contributing Artists:
KAREN BATES, JOHN COSTANZA, DAN DECARLO, MIKE DECARLO, FRANCIS DINGLASAN,
CHIA-HSIEN JASON HO, JAMES HUANG, JASON LATOUR, KIM LE, JAMES LLOYD,
OSCAR GONZALEZ LOYO, NATHAN KANE, ISTVAN MAJOROS, JOEY MASON, SCOTT MCRAE,
BILL MORRISON, JOEY NILGES, PHYLLIS NOVIN, PHIL ORTIZ, PATRICK OWSLEY, ANDREW PEPOY,
RICK REESE, RYAN RIVETTE, MIKE ROTE, HORACIO SANDOVAL, STEVE STEERE, JR.,
CHRIS UNGAR, ART VILLANUEVA, MIKE WORLEY
Contributing Writers:
JAMES BATES, TRACY BERNA, ABBY DENSON, TONY DIGEROLAMO, GEORGE GLADIR,
ROBERT L. GRAFF, CLINT JOHNSON, EARL KRESS, JESSE LEON MCCANN, GAIL SIMONE,
SHERRI L. SMITH, PATRIC VERRONE, CHRIS YAMBAR

PRINTED IN CANADA

TABLE OF CONTENTS

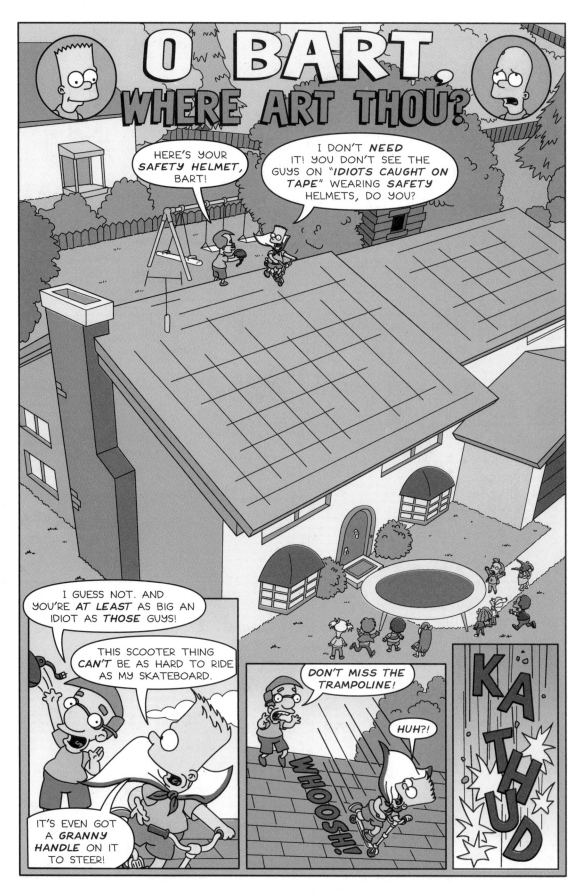

7

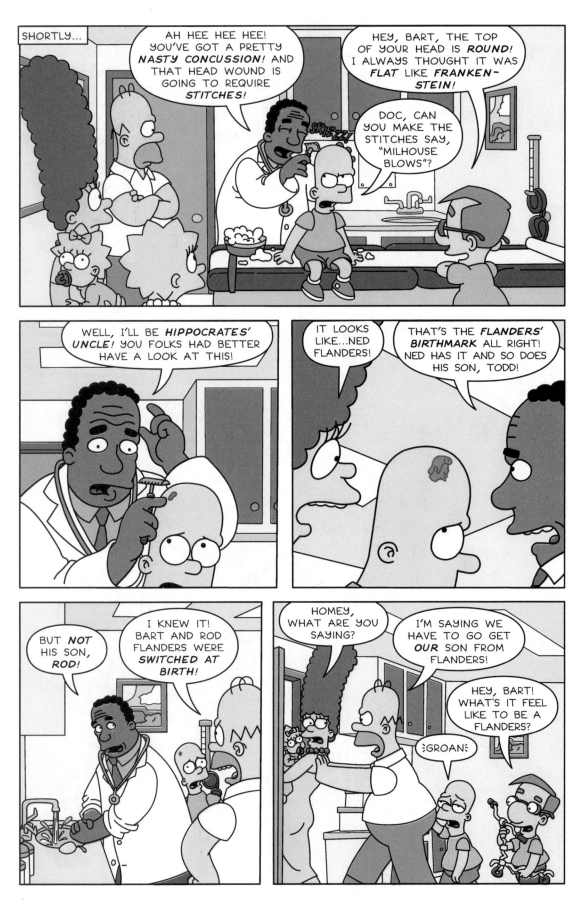

8

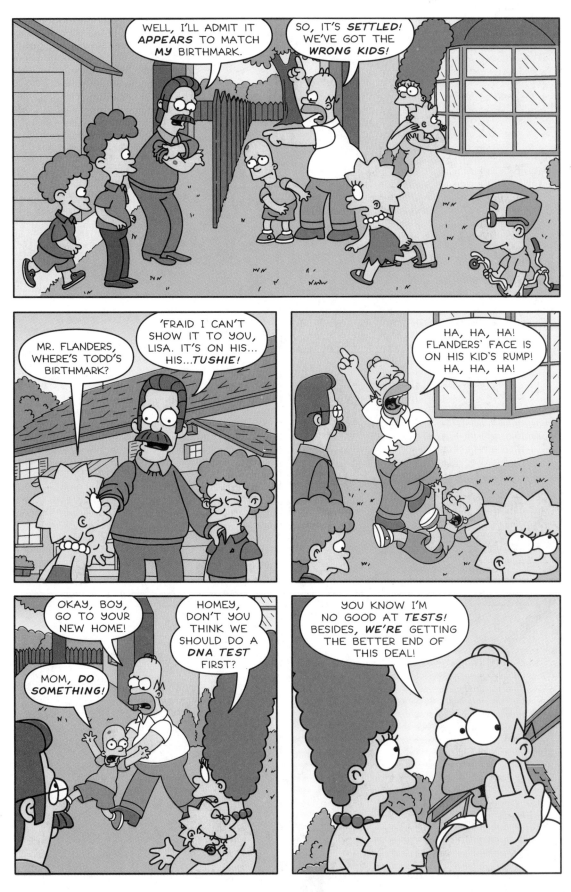

9

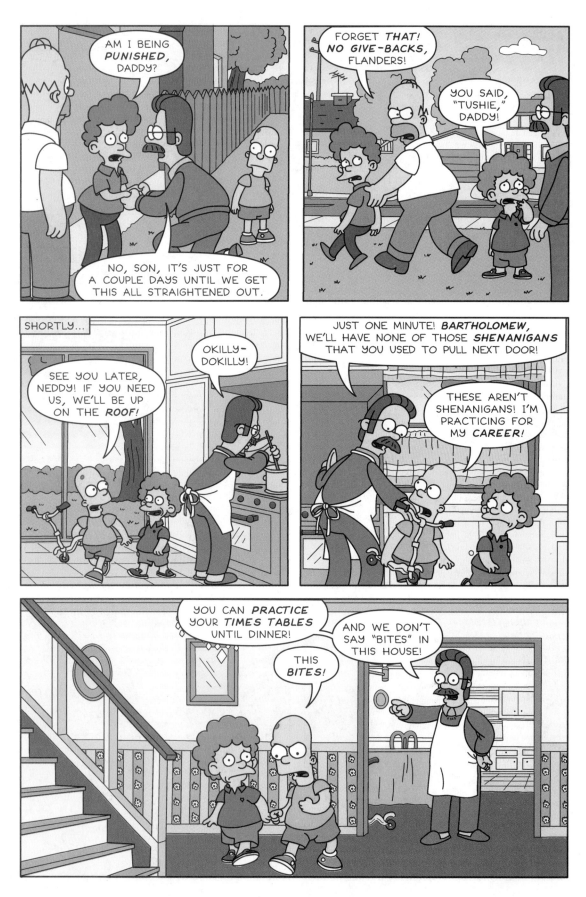

EARL KRESS STORY **DAN DECARLO** LAYOUTS **ISTVAN MAJOROS** PENCILS **JAMES HUANG** INKS **ART VILLANUEVA** COLORS **KAREN BATES** LETTERS **BILL MORRISON** EDITOR **MATT GROENING** MARKED FOR LIFE

"A CHAIR OF ONE'S OWN"

TONY DIGEROLAMO
STORY

RYAN RIVETTE
PENCILS

JASON HO
INKS

ART VILLANUEVA
COLORS

KAREN BATES
LETTERS

BILL MORRISON
EDITOR

MATT GROENING
BOOKWORM

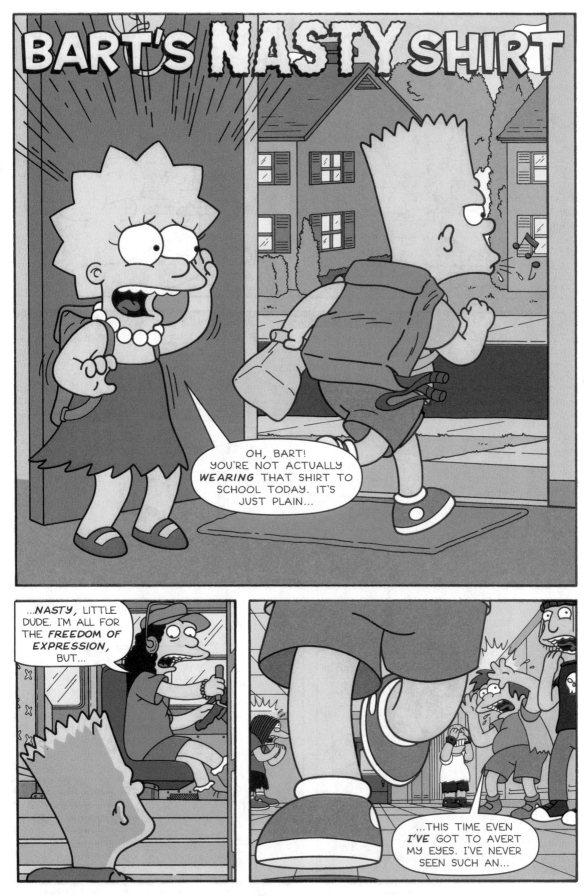

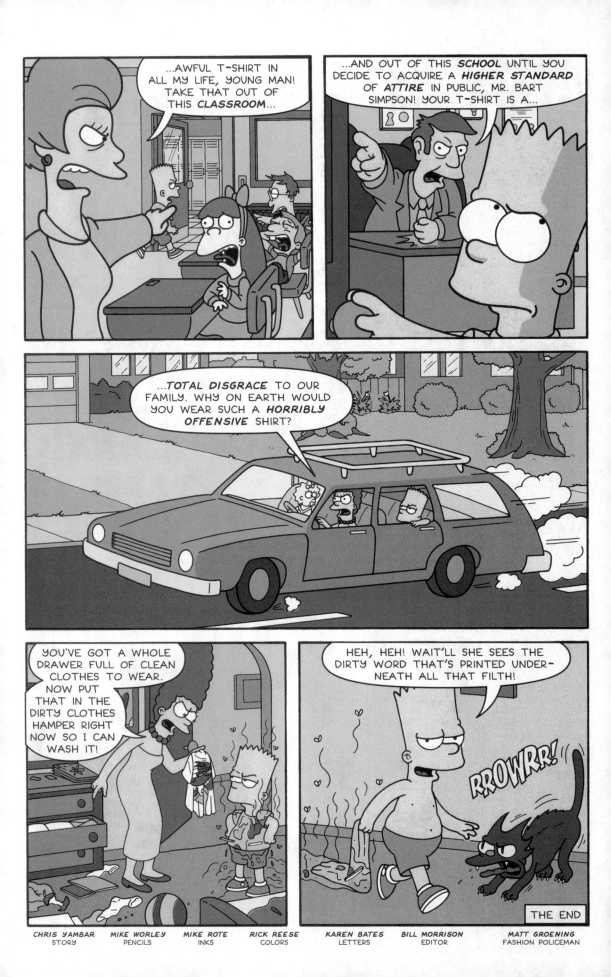

CHRIS YAMBAR
STORY

MIKE WORLEY
PENCILS

MIKE ROTE
INKS

RICK REESE
COLORS

KAREN BATES
LETTERS

BILL MORRISON
EDITOR

MATT GROENING
FASHION POLICEMAN

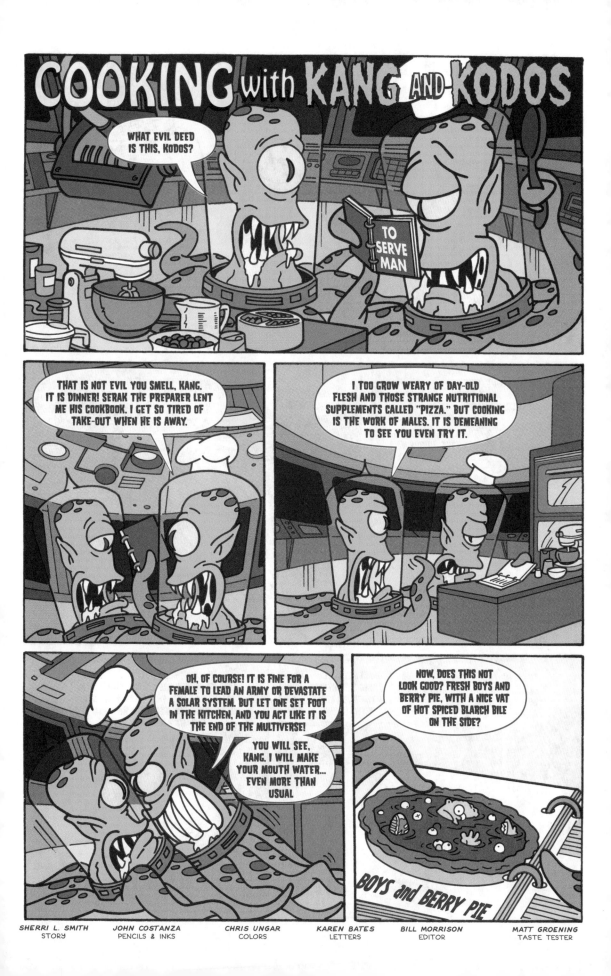

SHERRI L. SMITH
STORY

JOHN COSTANZA
PENCILS & INKS

CHRIS UNGAR
COLORS

KAREN BATES
LETTERS

BILL MORRISON
EDITOR

MATT GROENING
TASTE TESTER

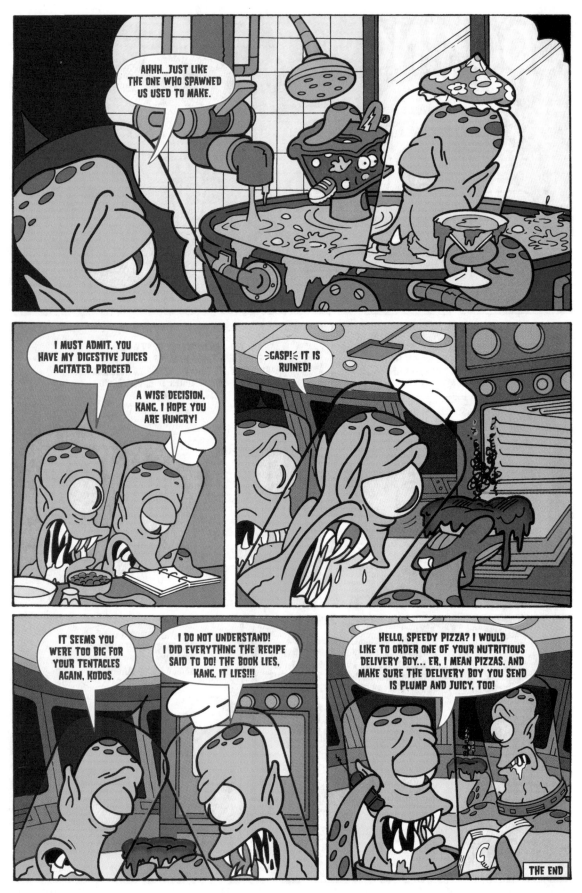

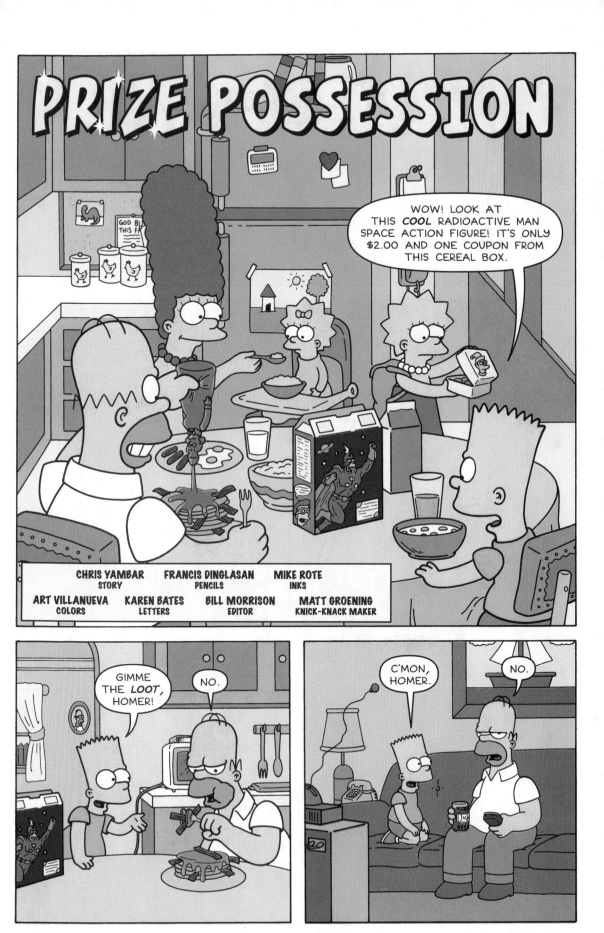

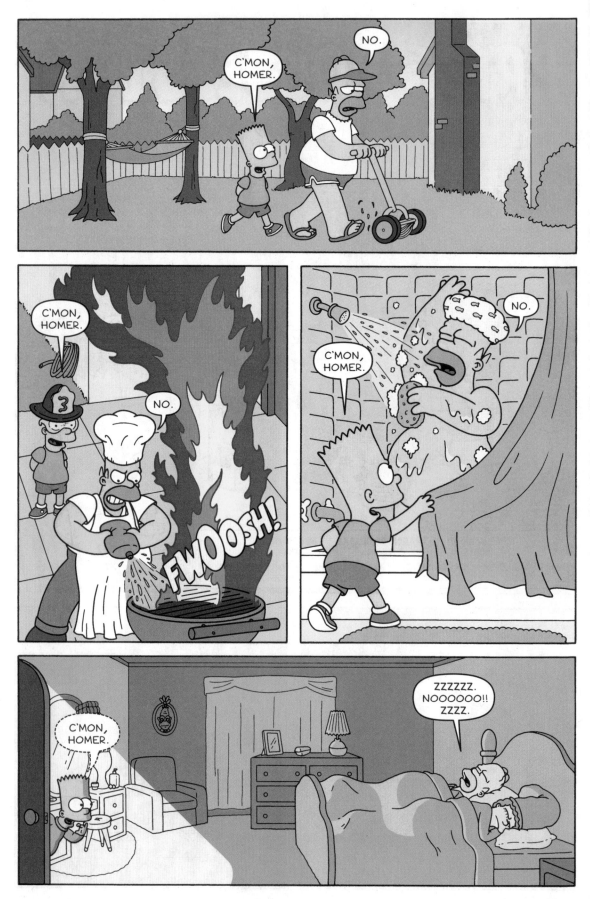

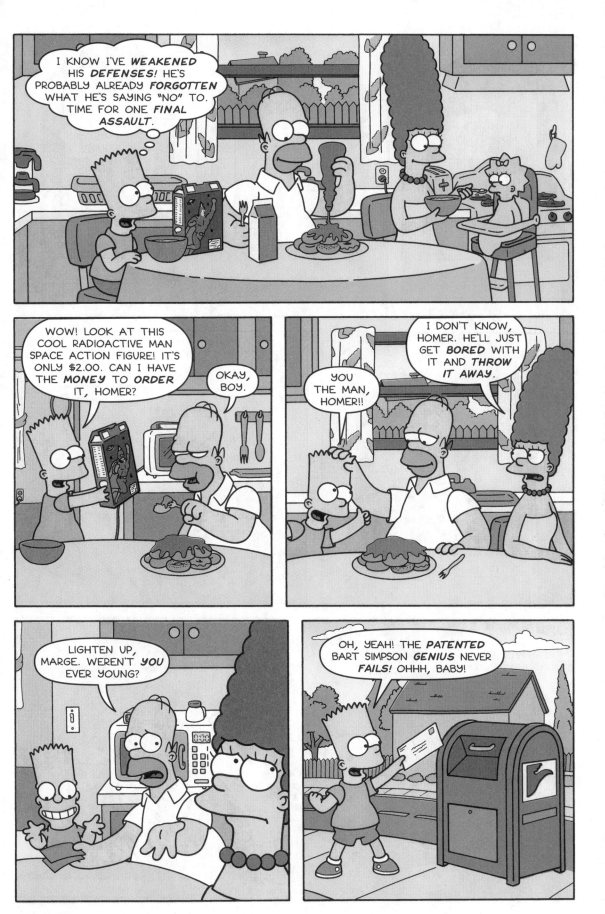

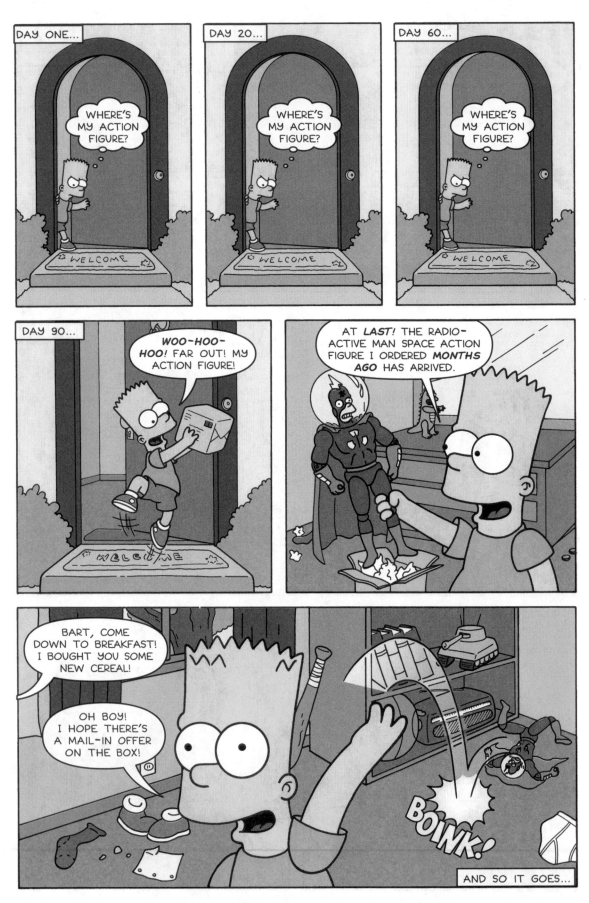

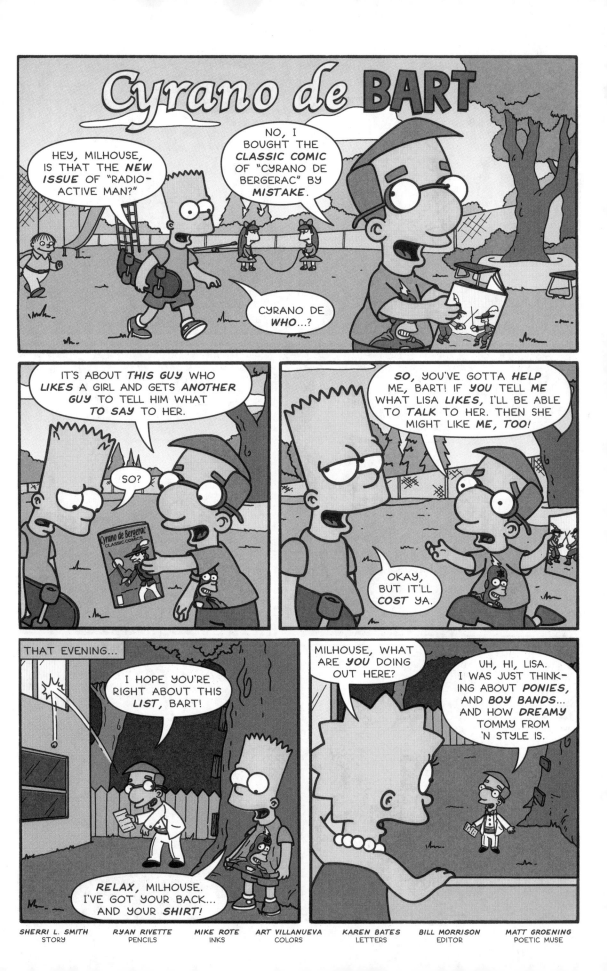

SHERRI L. SMITH
STORY

RYAN RIVETTE
PENCILS

MIKE ROTE
INKS

ART VILLANUEVA
COLORS

KAREN BATES
LETTERS

BILL MORRISON
EDITOR

MATT GROENING
POETIC MUSE

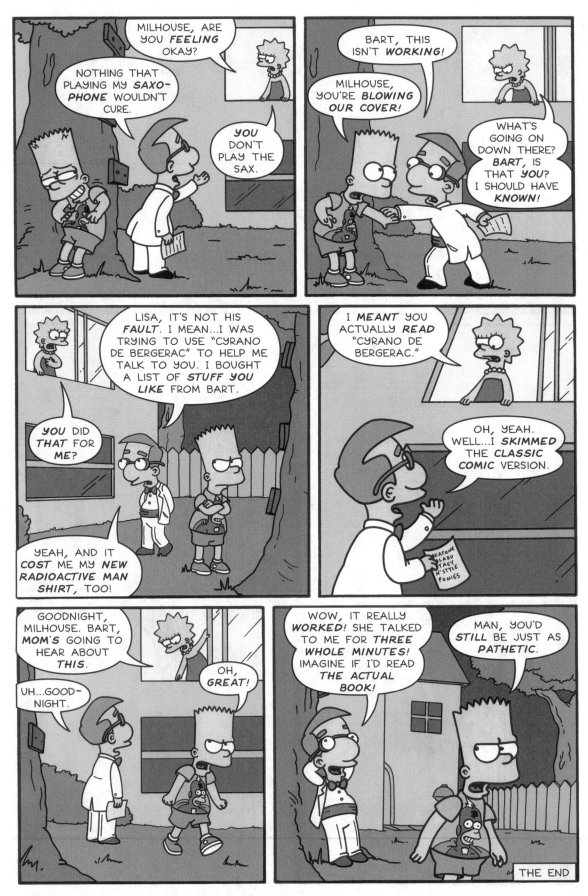

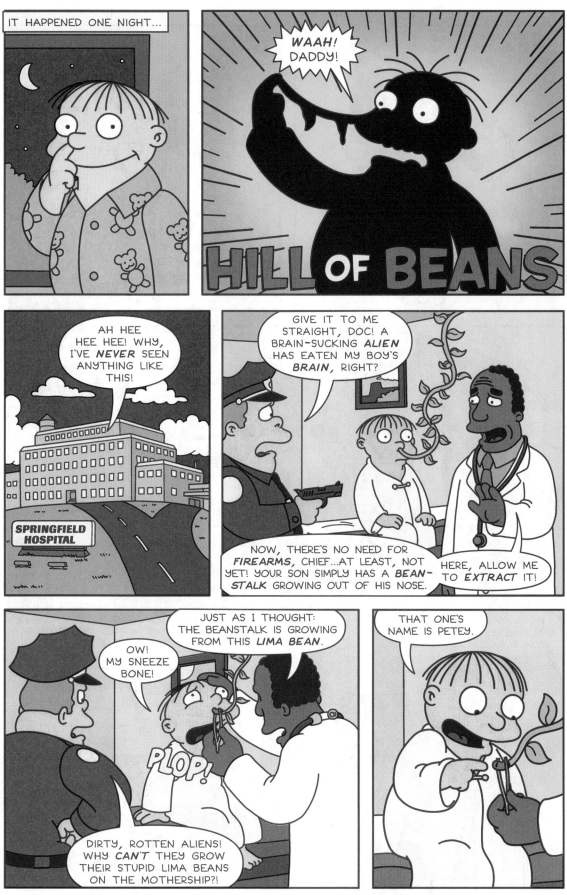

ROBERT L. GRAFF & JESSE LEON MCCANN
STORY

JOEY NILGES
PENCILS

JAMES HUANG
INKS

RICK REESE
COLORS

KAREN BATES
LETTERS

BILL MORRISON
EDITOR

MATT GROENING
BEAN COUNTER

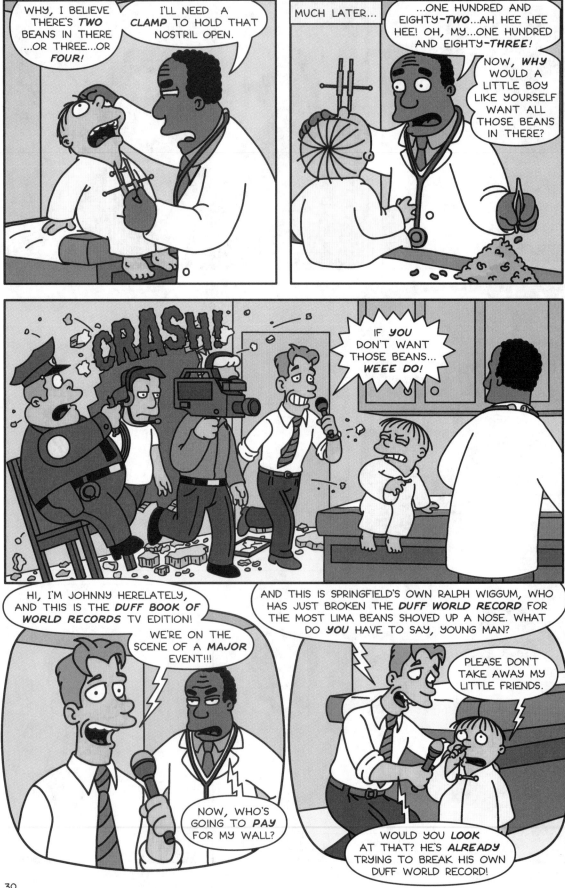

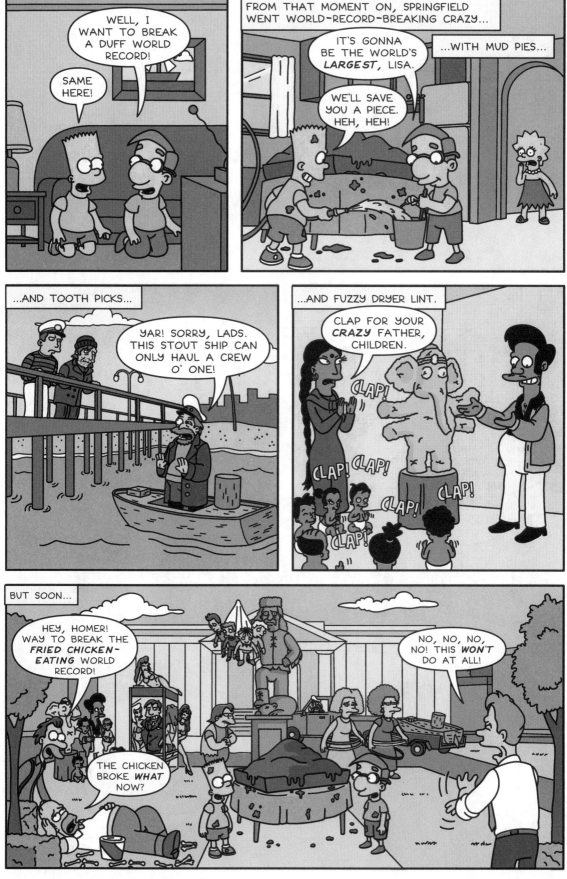

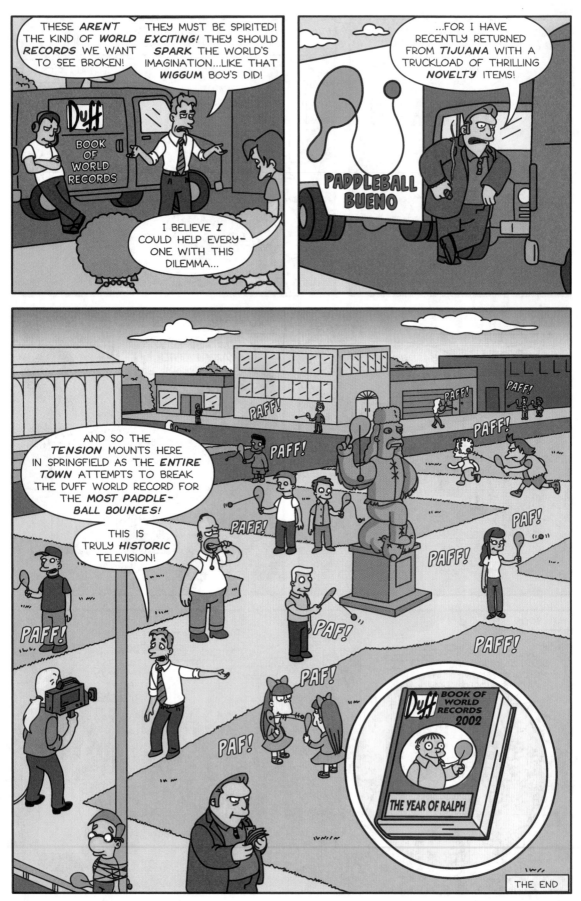

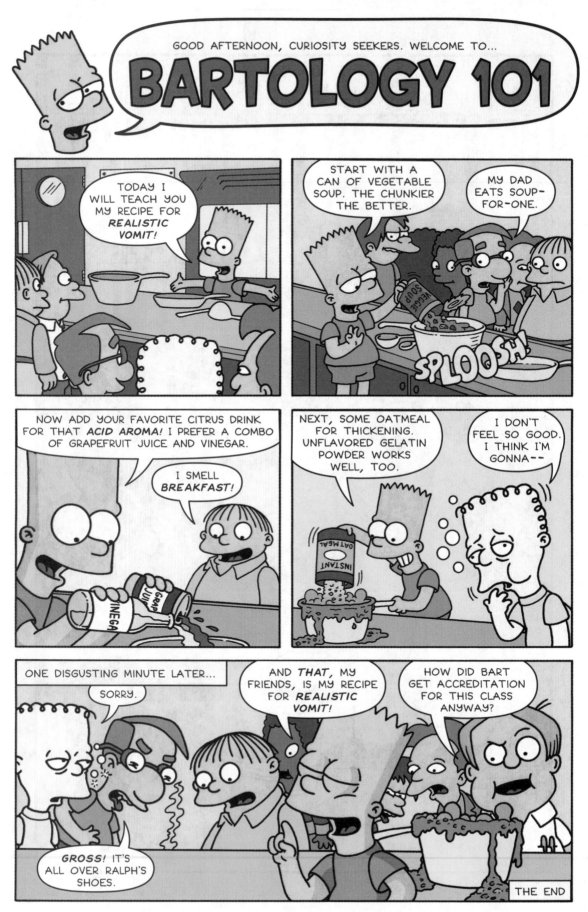

34

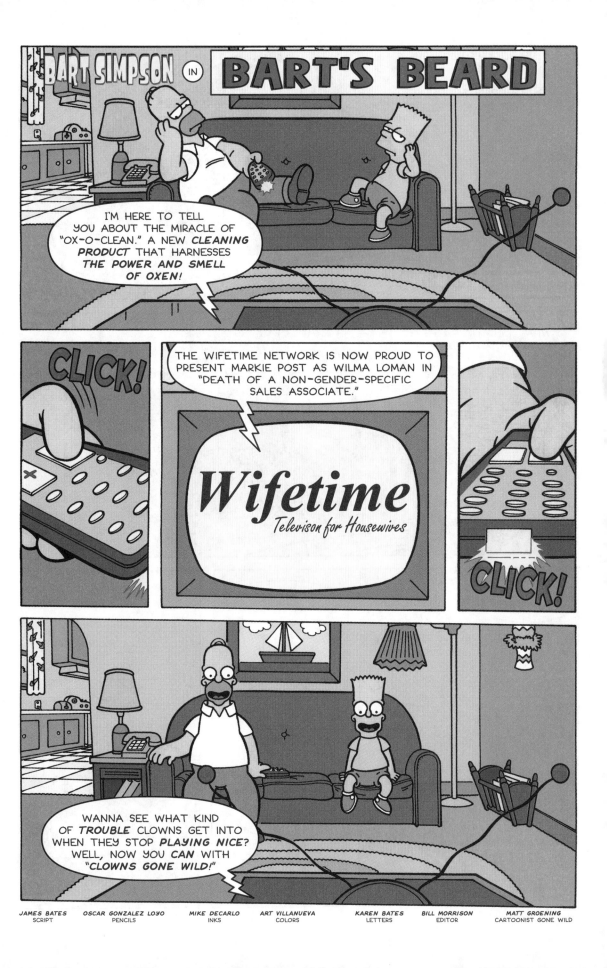

JAMES BATES
SCRIPT

OSCAR GONZALEZ LOYO
PENCILS

MIKE DECARLO
INKS

ART VILLANUEVA
COLORS

KAREN BATES
LETTERS

BILL MORRISON
EDITOR

MATT GROENING
CARTOONIST GONE WILD

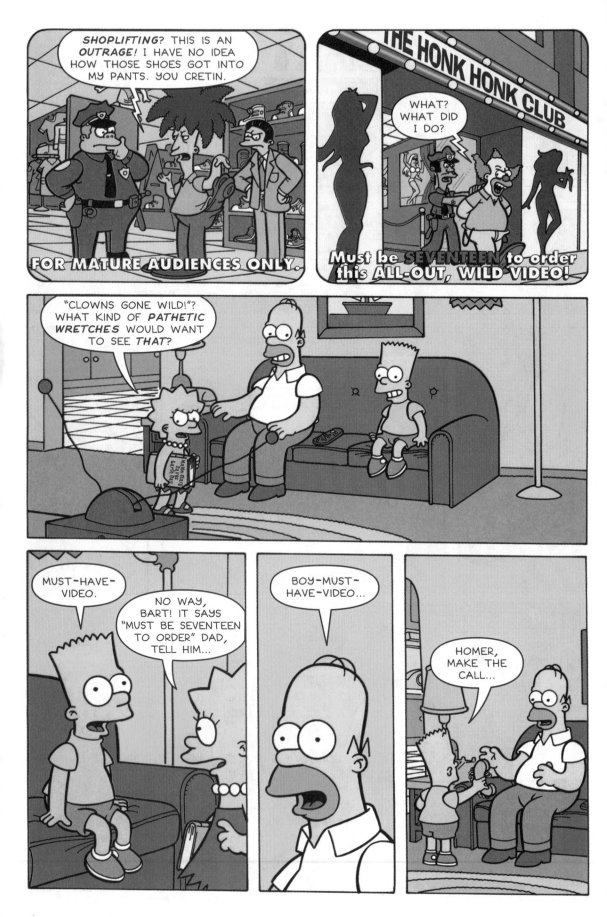

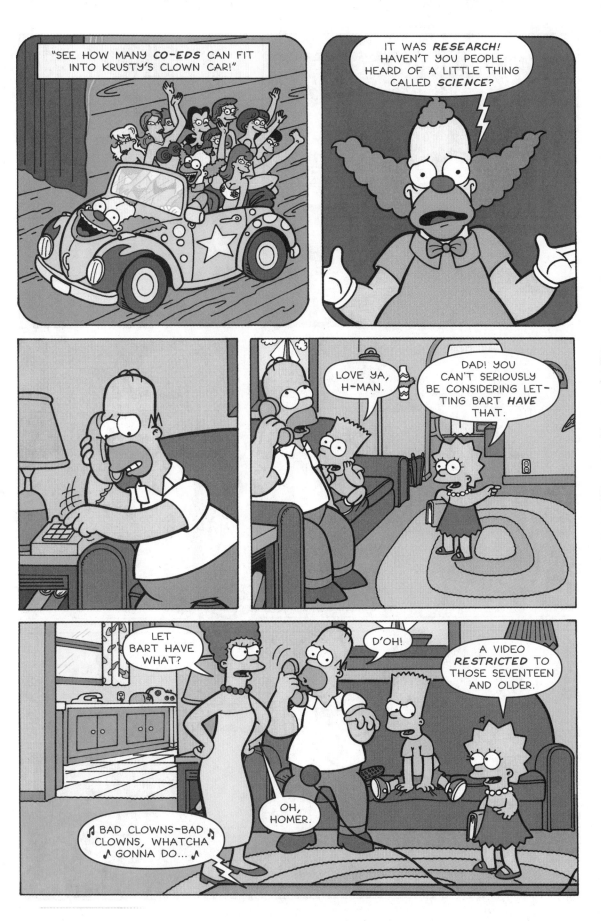

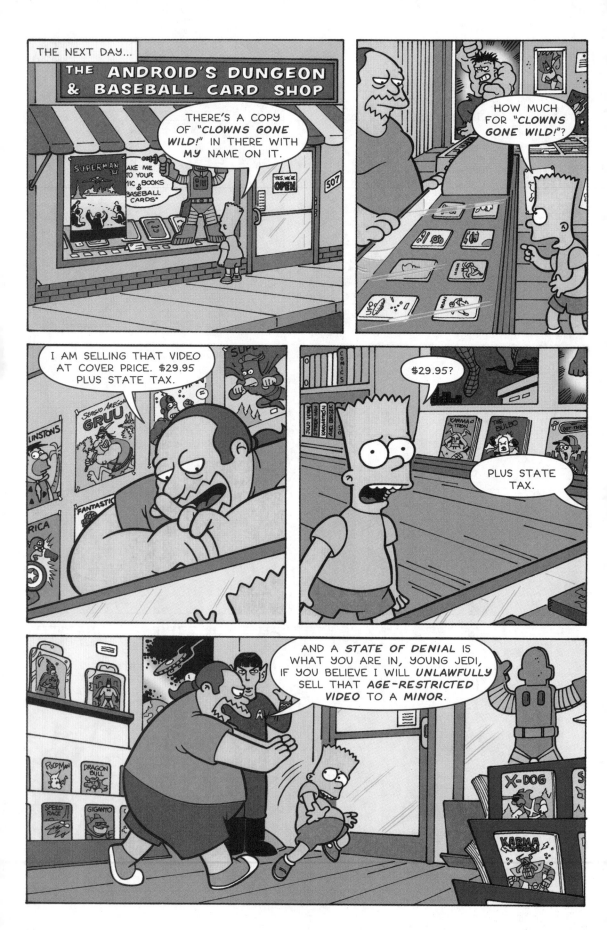

38

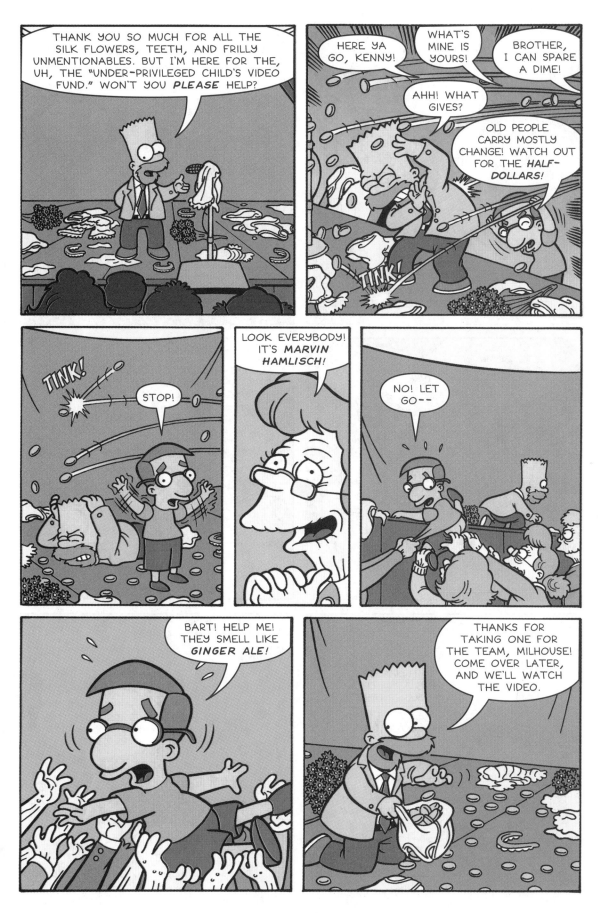

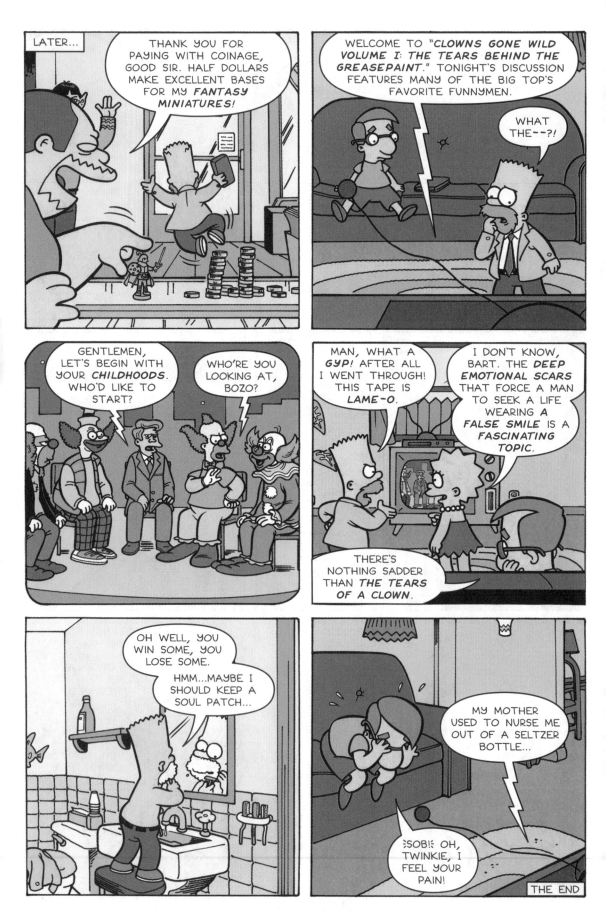

44

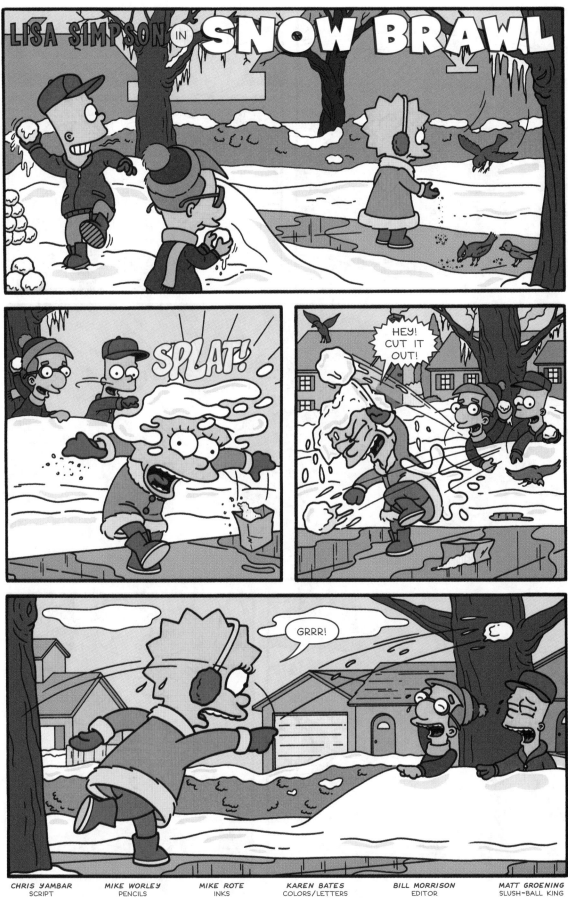

CHRIS YAMBAR
SCRIPT

MIKE WORLEY
PENCILS

MIKE ROTE
INKS

KAREN BATES
COLORS/LETTERS

BILL MORRISON
EDITOR

MATT GROENING
SLUSH-BALL KING

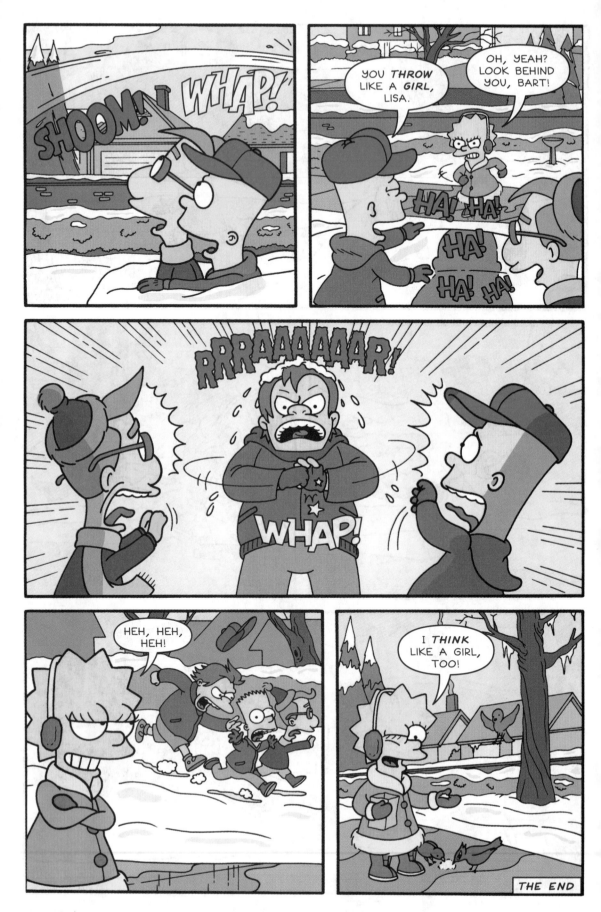

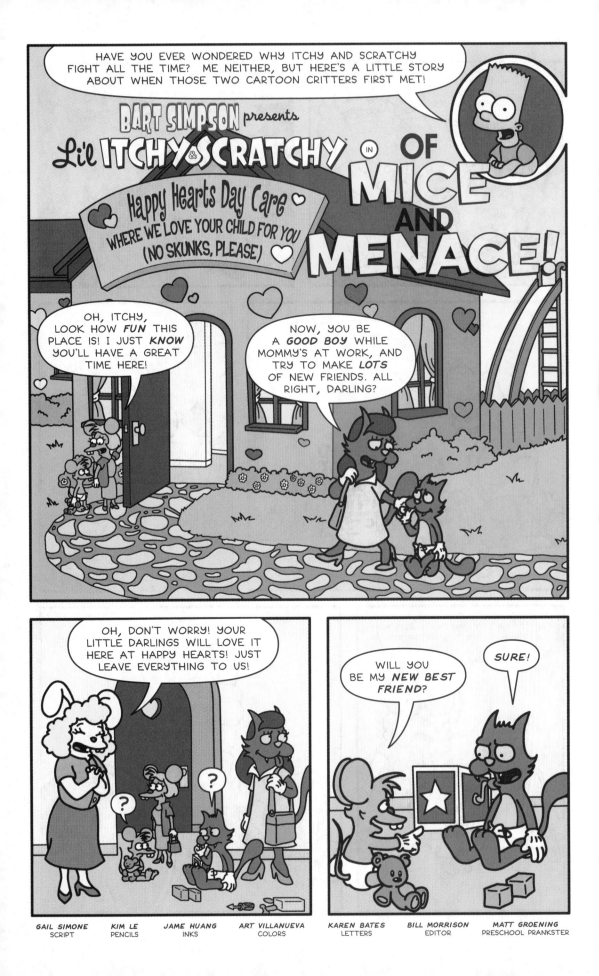

GAIL SIMONE
SCRIPT

KIM LE
PENCILS

JAME HUANG
INKS

ART VILLANUEVA
COLORS

KAREN BATES
LETTERS

BILL MORRISON
EDITOR

MATT GROENING
PRESCHOOL PRANKSTER

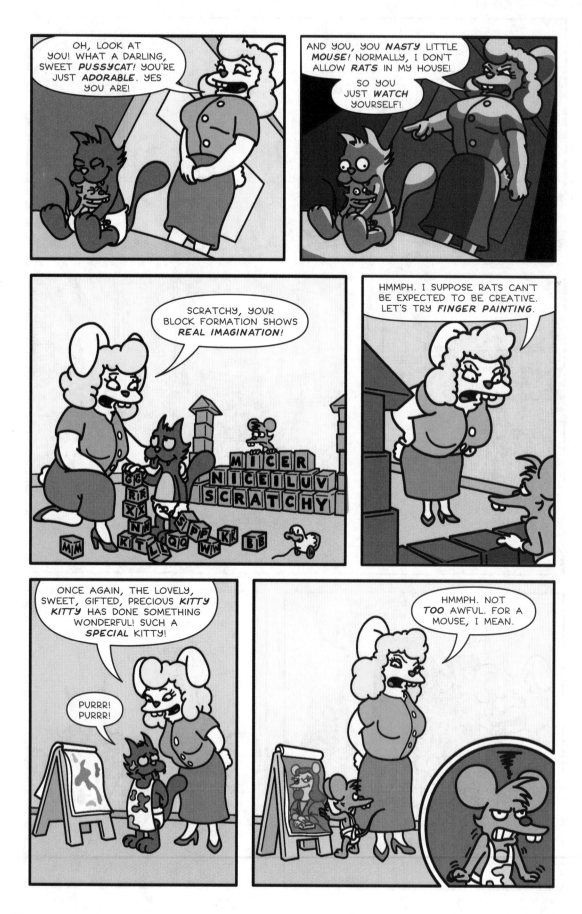

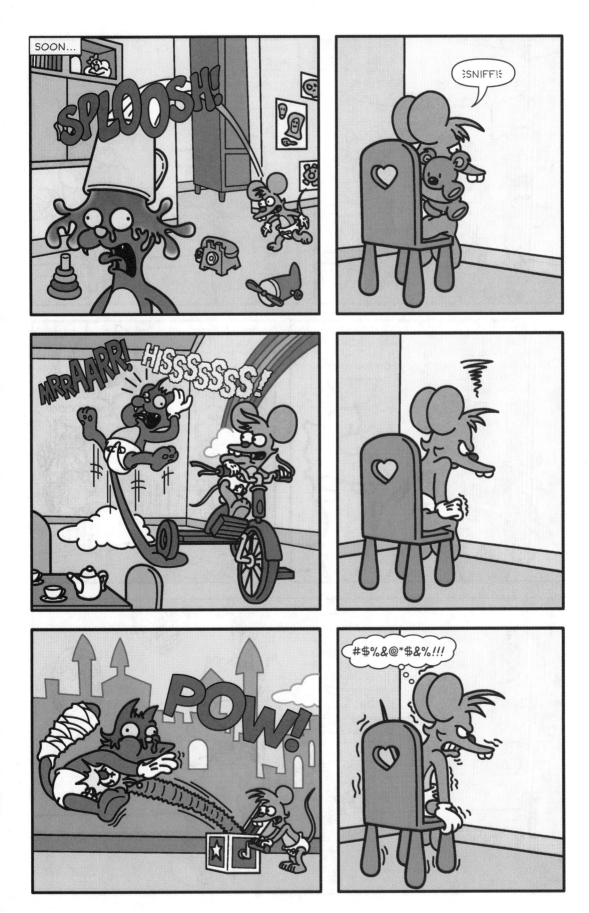

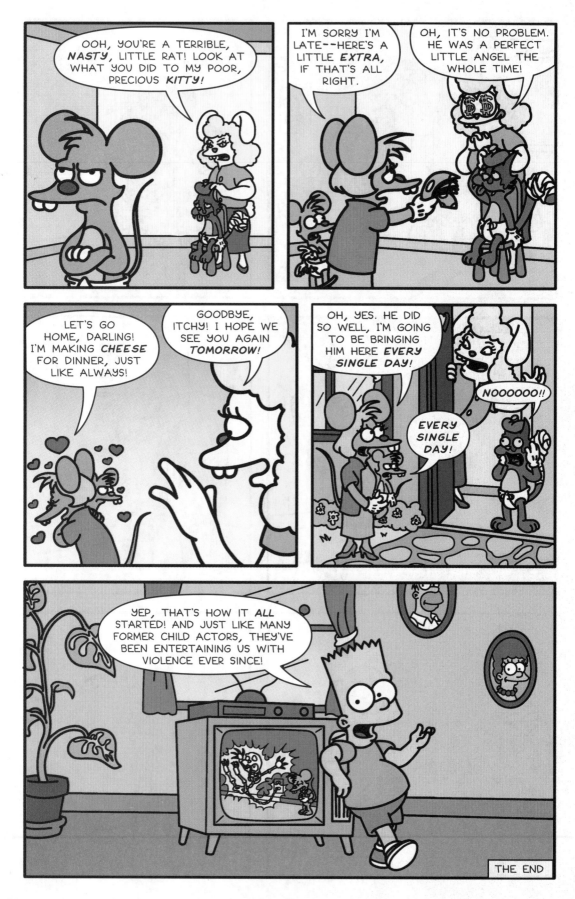

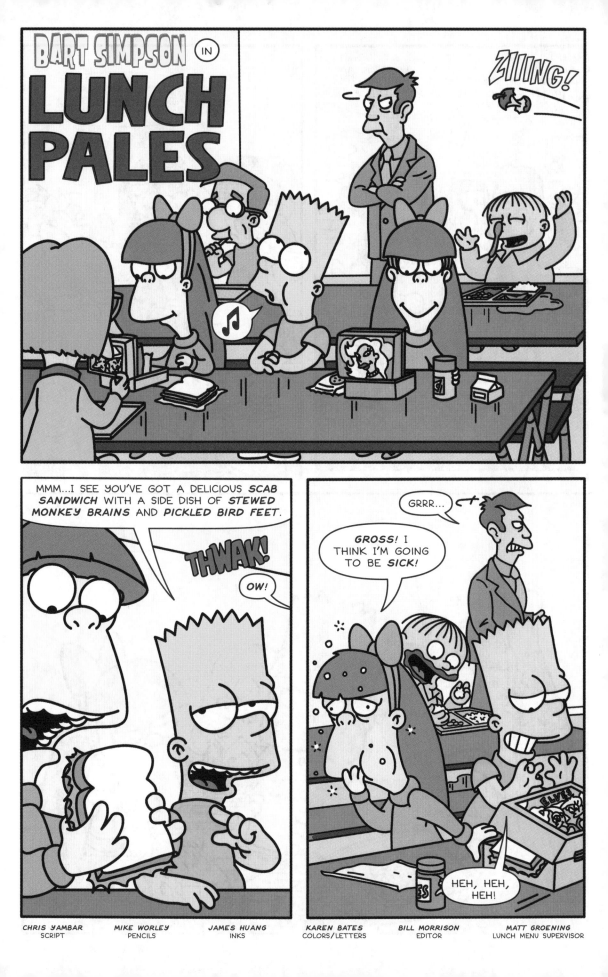

CHRIS YAMBAR
SCRIPT

MIKE WORLEY
PENCILS

JAMES HUANG
INKS

KAREN BATES
COLORS/LETTERS

BILL MORRISON
EDITOR

MATT GROENING
LUNCH MENU SUPERVISOR

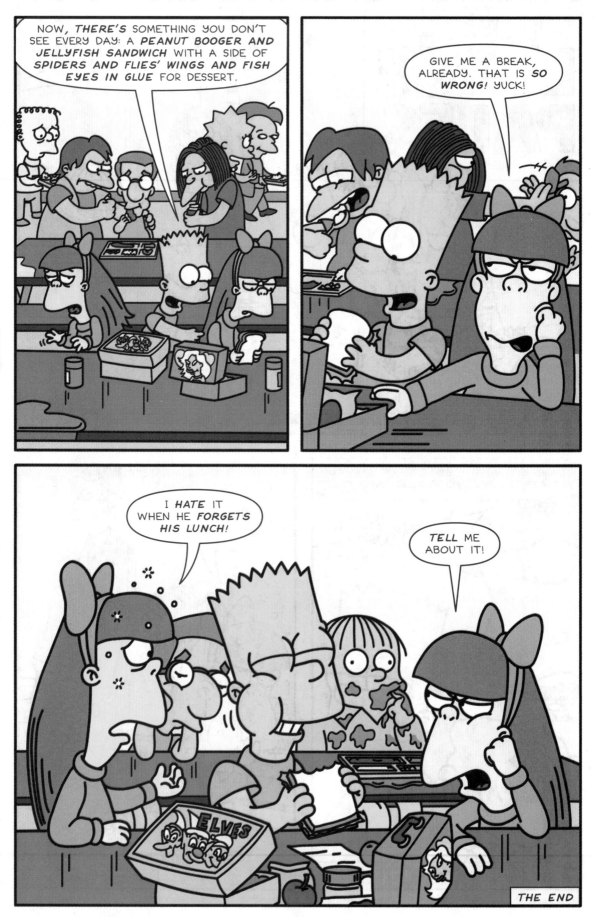

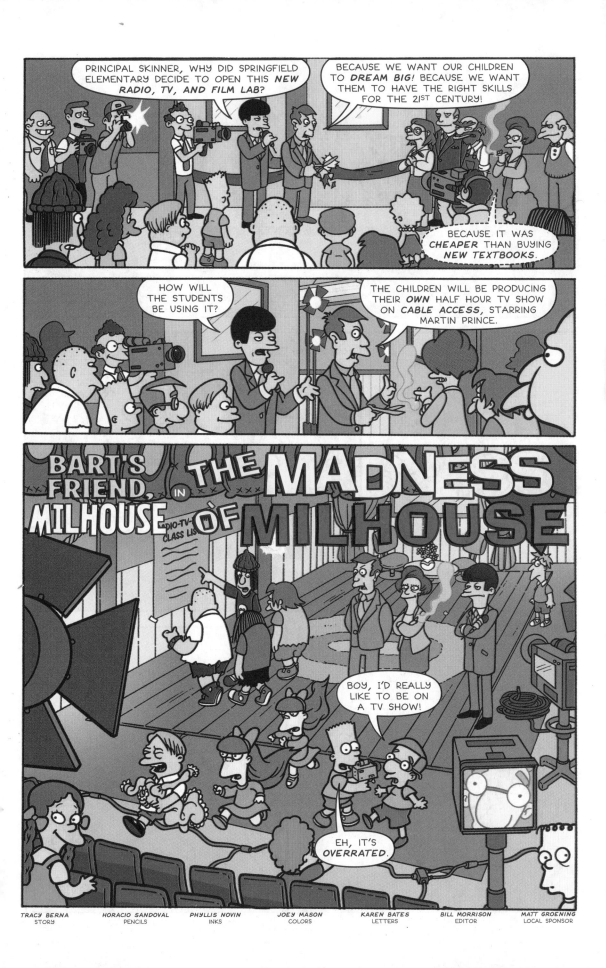

TRACY BERNA
STORY

HORACIO SANDOVAL
PENCILS

PHYLLIS NOVIN
INKS

JOEY MASON
COLORS

KAREN BATES
LETTERS

BILL MORRISON
EDITOR

MATT GROENING
LOCAL SPONSOR

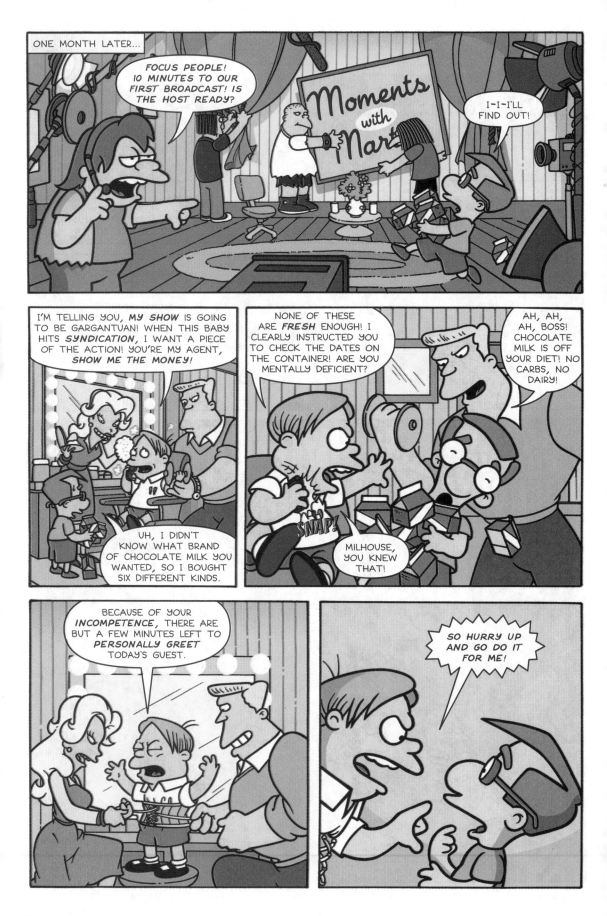

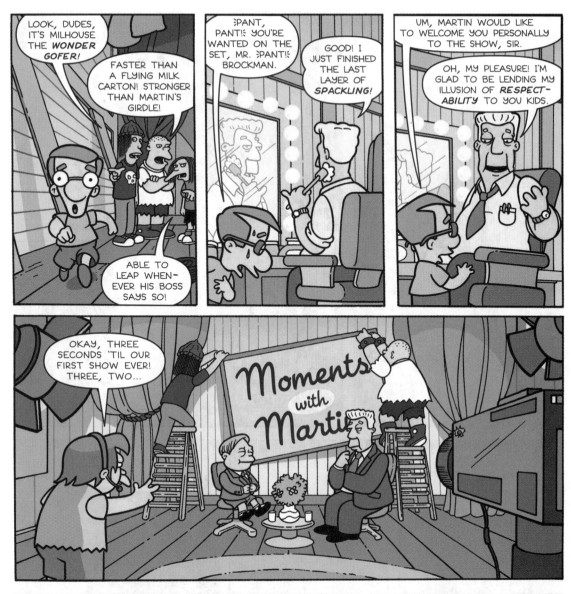

LOOK, DUDES, IT'S MILHOUSE THE *WONDER GOFER!*

FASTER THAN A FLYING MILK CARTON! STRONGER THAN MARTIN'S GIRDLE!

ABLE TO LEAP WHEN-EVER HIS BOSS SAYS SO!

:PANT, PANT!: YOU'RE WANTED ON THE SET, MR. :PANT!: BROCKMAN.

GOOD! I JUST FINISHED THE LAST LAYER OF *SPACKLING!*

UM, MARTIN WOULD LIKE TO WELCOME YOU PERSONALLY TO THE SHOW, SIR.

OH, MY PLEASURE! I'M GLAD TO BE LENDING MY ILLUSION OF *RESPECT-ABILITY* TO YOU KIDS.

OKAY, THREE SECONDS 'TIL OUR FIRST SHOW EVER! THREE, TWO...

Moments with Marti

...ONE ...YOU'RE ON!

UNNNHHH...

SAY SOMETHING, KID!

55

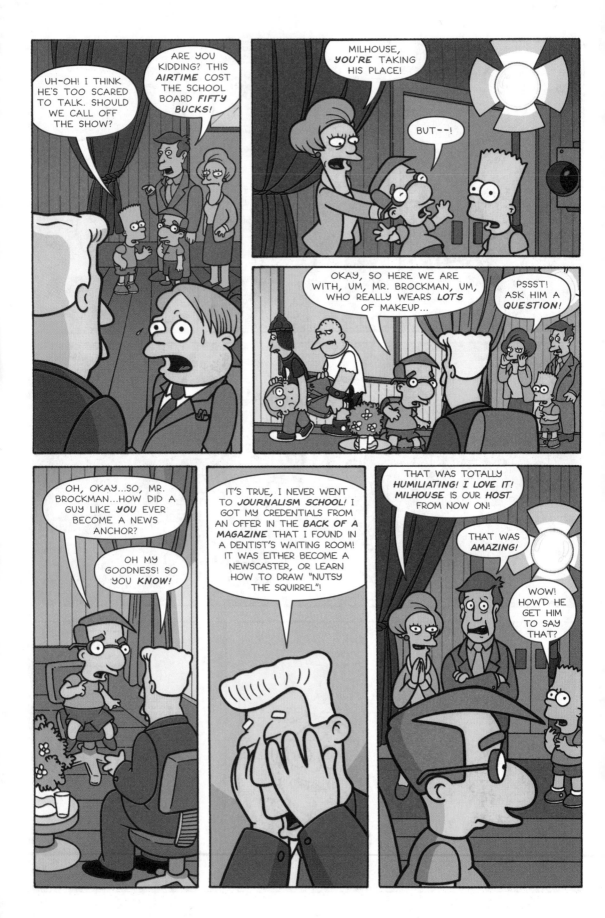

UH-OH! I THINK HE'S TOO SCARED TO TALK. SHOULD WE CALL OFF THE SHOW?

ARE YOU KIDDING? THIS *AIRTIME* COST THE SCHOOL BOARD *FIFTY BUCKS!*

MILHOUSE, *YOU'RE* TAKING HIS PLACE!

BUT--!

OKAY, SO HERE WE ARE WITH, UM, MR. BROCKMAN, UM, WHO REALLY WEARS *LOTS* OF MAKEUP...

PSSST! ASK HIM A *QUESTION!*

OH, OKAY...SO, MR. BROCKMAN...HOW DID A GUY LIKE *YOU* EVER BECOME A NEWS ANCHOR?

OH MY GOODNESS! SO *YOU* *KNOW!*

IT'S TRUE, I NEVER WENT TO *JOURNALISM SCHOOL!* I GOT MY CREDENTIALS FROM AN OFFER IN THE *BACK OF A MAGAZINE* THAT I FOUND IN A DENTIST'S WAITING ROOM! IT WAS EITHER BECOME A NEWSCASTER, OR LEARN HOW TO DRAW "NUTSY THE SQUIRREL"!

THAT WAS TOTALLY *HUMILIATING! I LOVE IT! MILHOUSE* IS OUR *HOST* FROM NOW ON!

THAT WAS *AMAZING!*

WOW! HOW'D HE GET HIM TO SAY THAT?

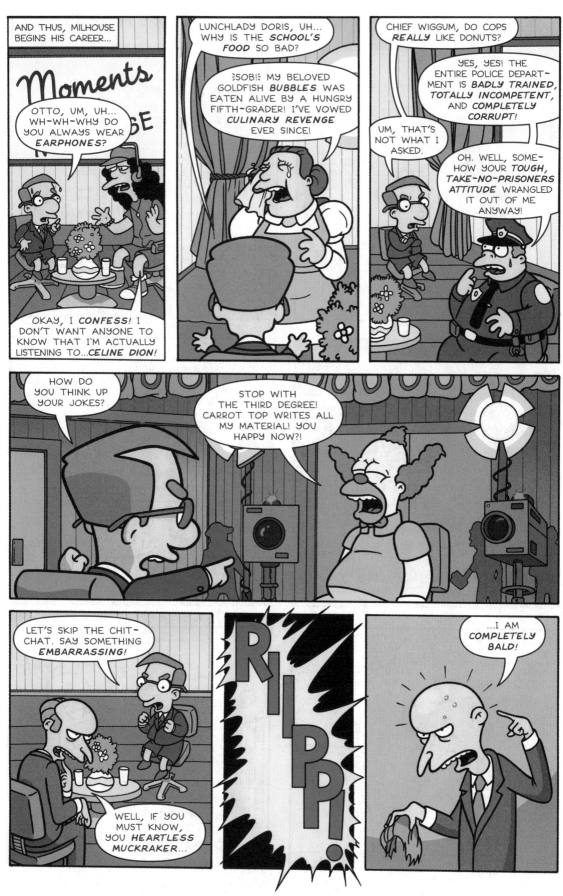

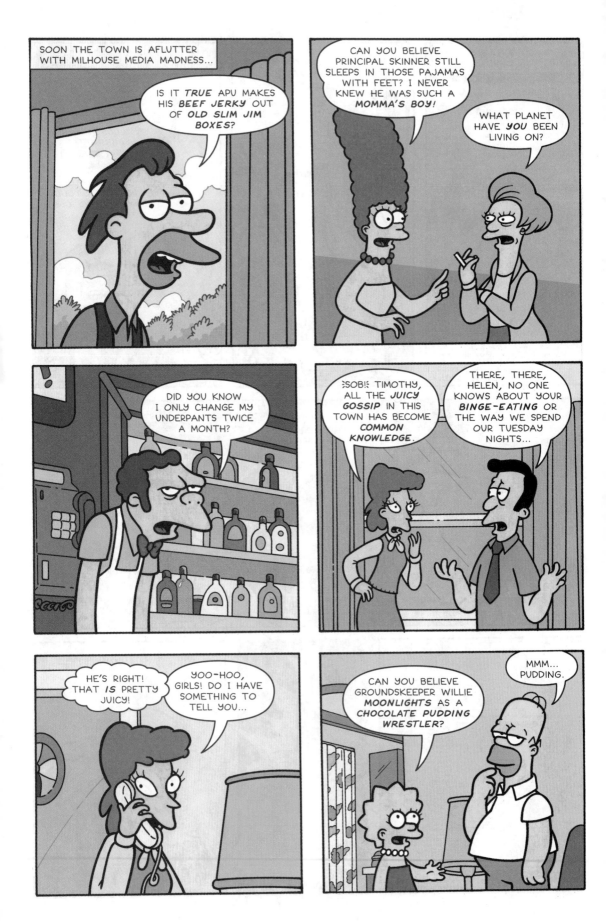

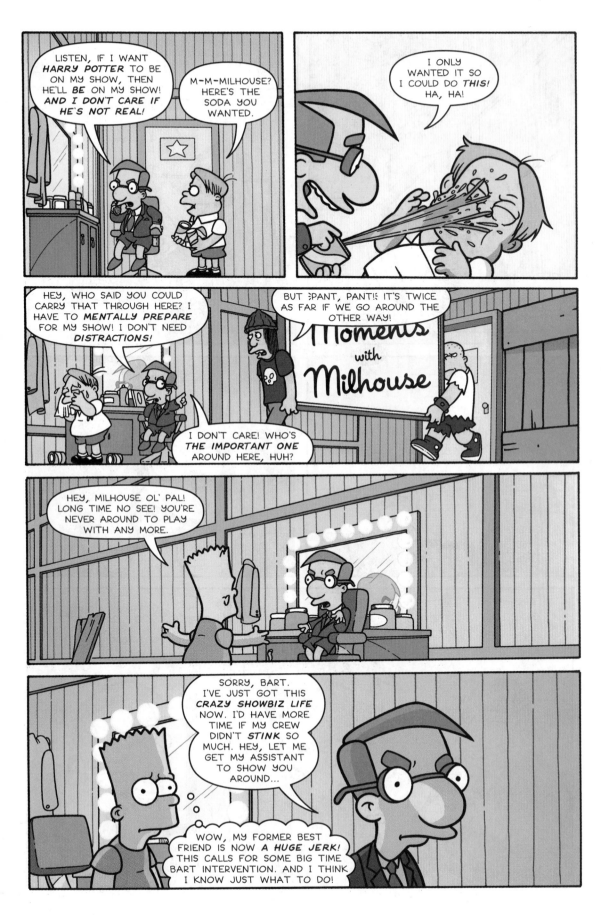

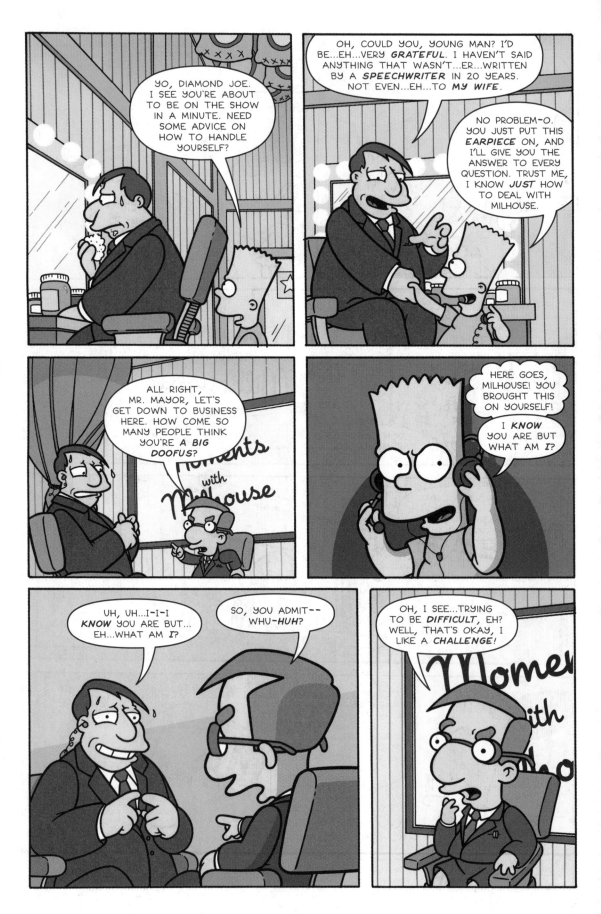

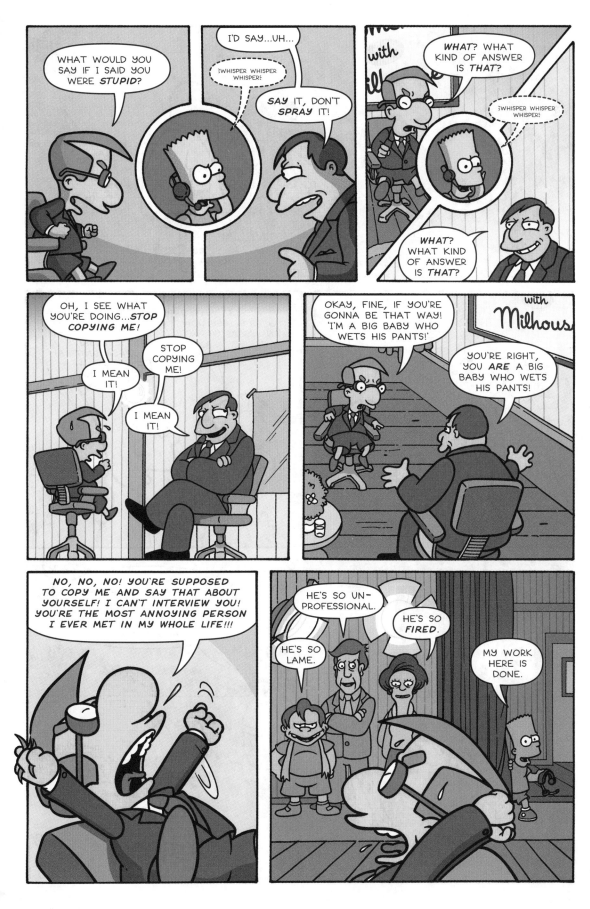

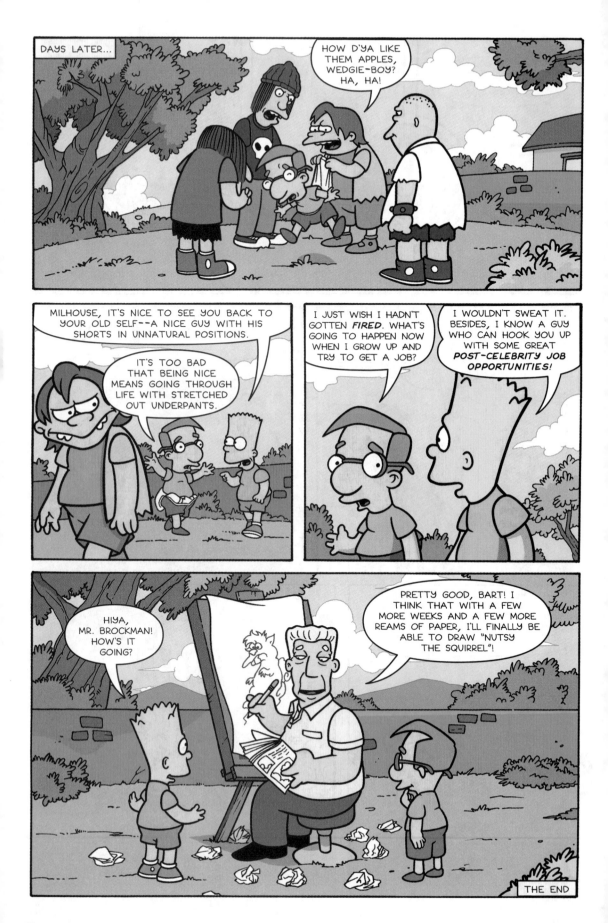

FROM LICHTENSLAVA WITH LOVE

JAMES BATES
SCRIPT

ISTVAN MAJOROS
PENCILS

JAMES HUANG
INKS

NATHAN UNGARNUEVA
COLORS

KAREN BATES
LETTERS

BILL MORRISON
EDITOR

MATT GROENING
JUSTICE OF THE PEACE

THIS IS **VERY IMPORTANT**, CHILDREN. THERE ARE MANY PEOPLE WHO WILL TAKE **ADVANTAGE** OF YOU THROUGH THE MAIL.

AS A YOUNGSTER, I MAILED IN TO JOIN *THE HERMAN'S HERMITS FAN CLUB* AND THREE *STAMPS* AND TWO *PROOFS OF PURCHASE* LATER, I FOUND MYSELF ENLISTED IN THE *VIETNAM WAR*.

HhIiJjKkLlMmNnOoPpQqRrSsTtUuVvWwXxYyZz

MAIL-ORDER SCAMS

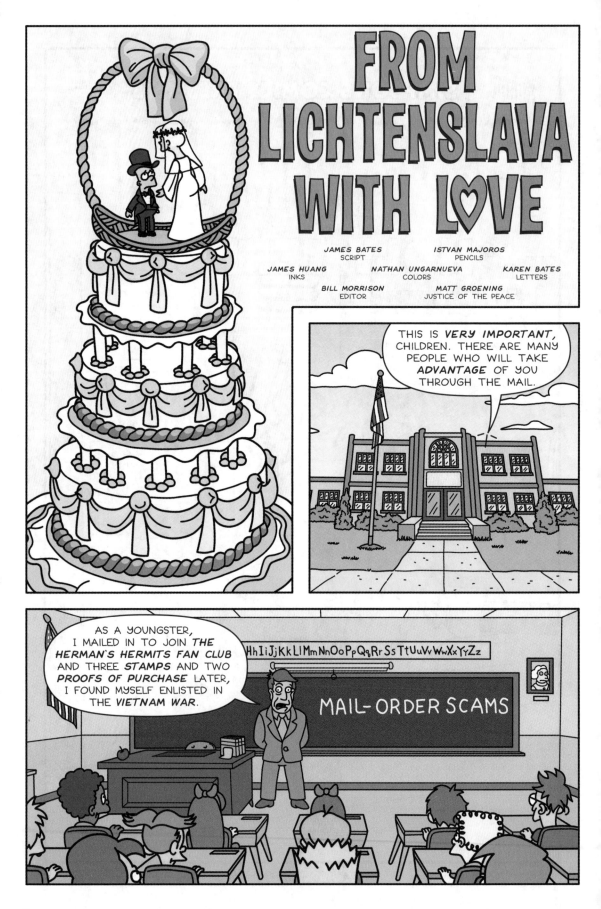

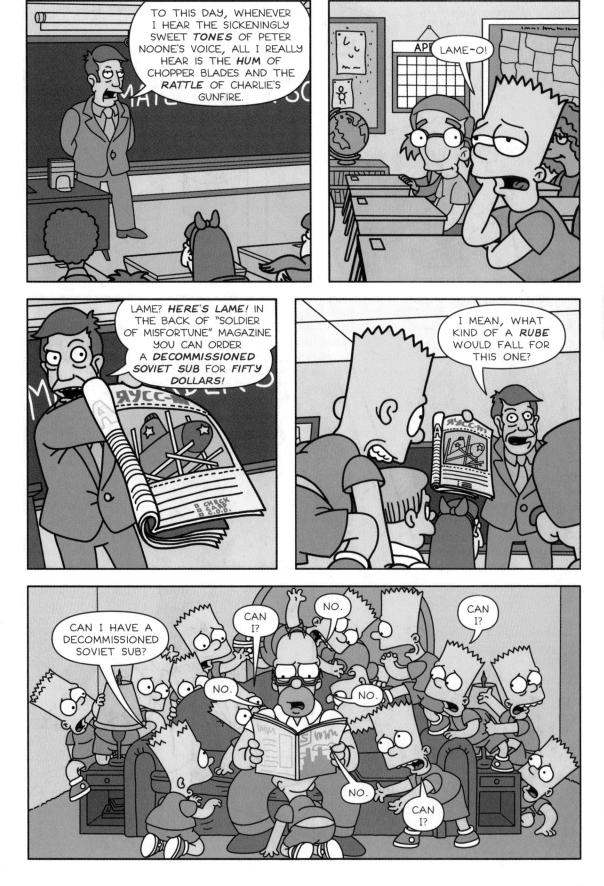

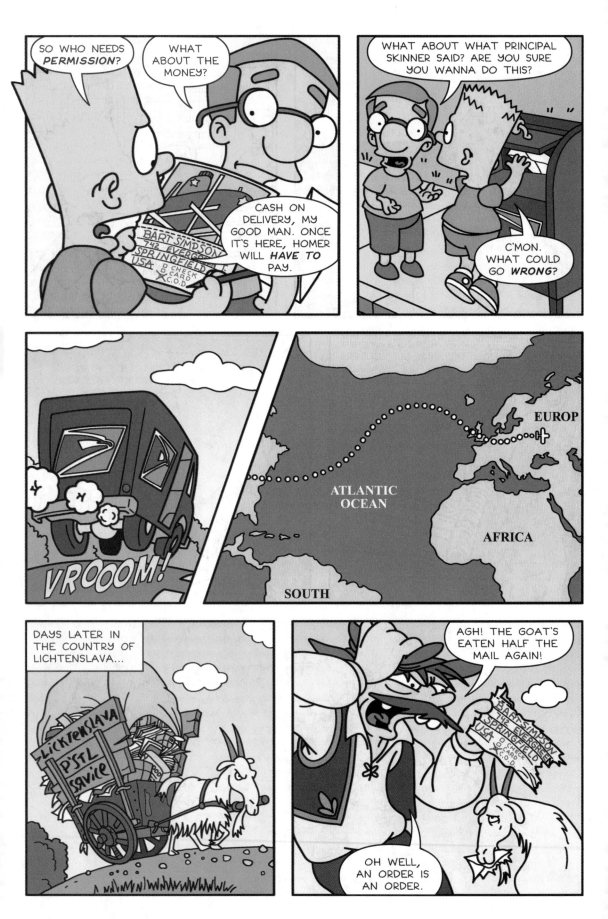

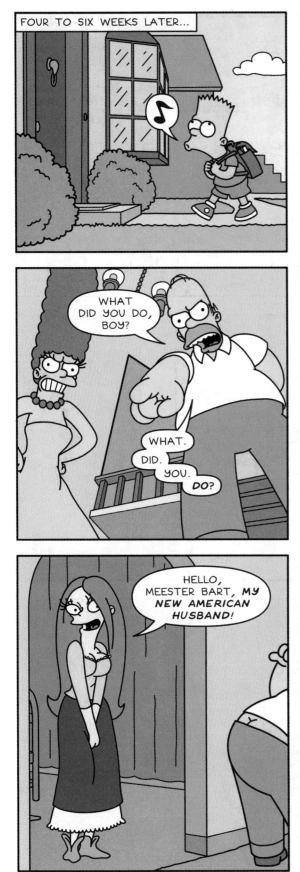

FOUR TO SIX WEEKS LATER...

UH-OH.

WHAT DID YOU DO, BOY?

WHAT. DID. YOU. *DO?*

HELLO, MEESTER BART, *MY NEW AMERICAN HUSBAND!*

YOU KNOW ME. *I* DIDN'T DO IT.

THEN HOW DO YOU EXPLAIN *THAT?*

AYE, CARUMBA!

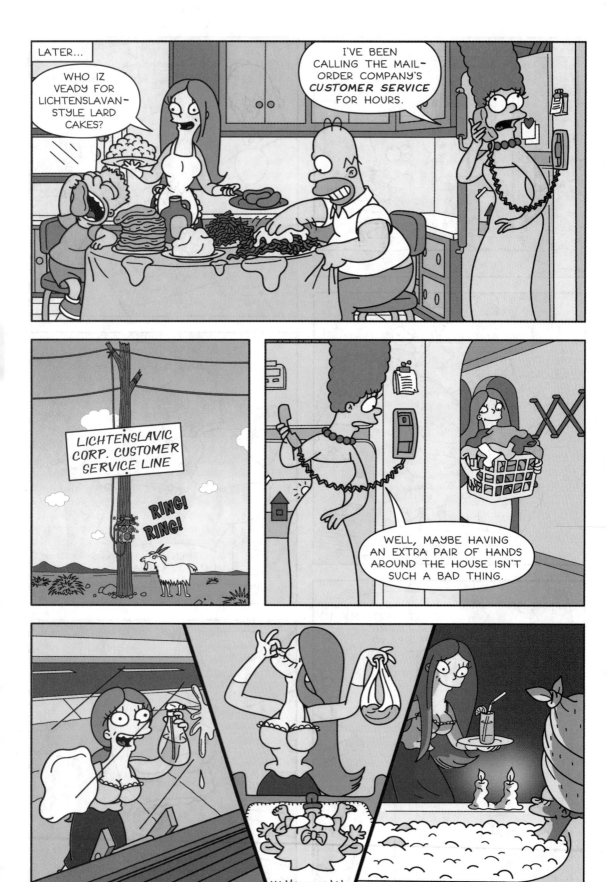

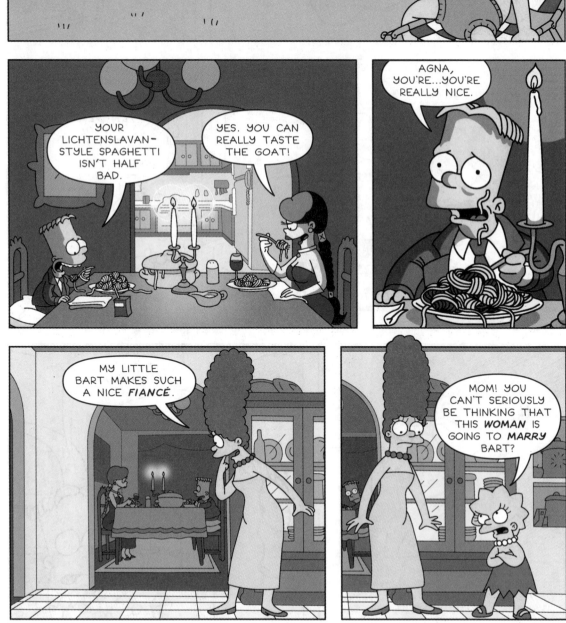

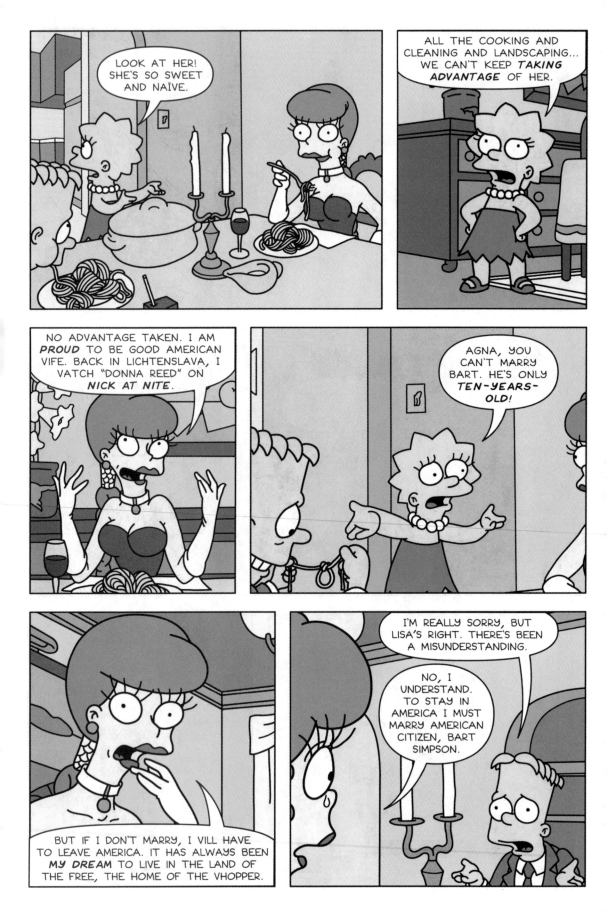

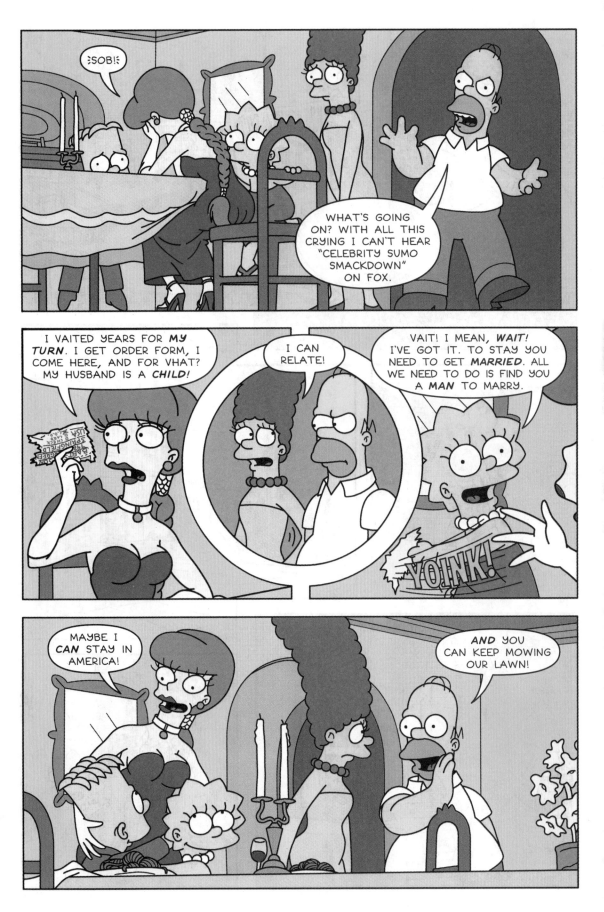

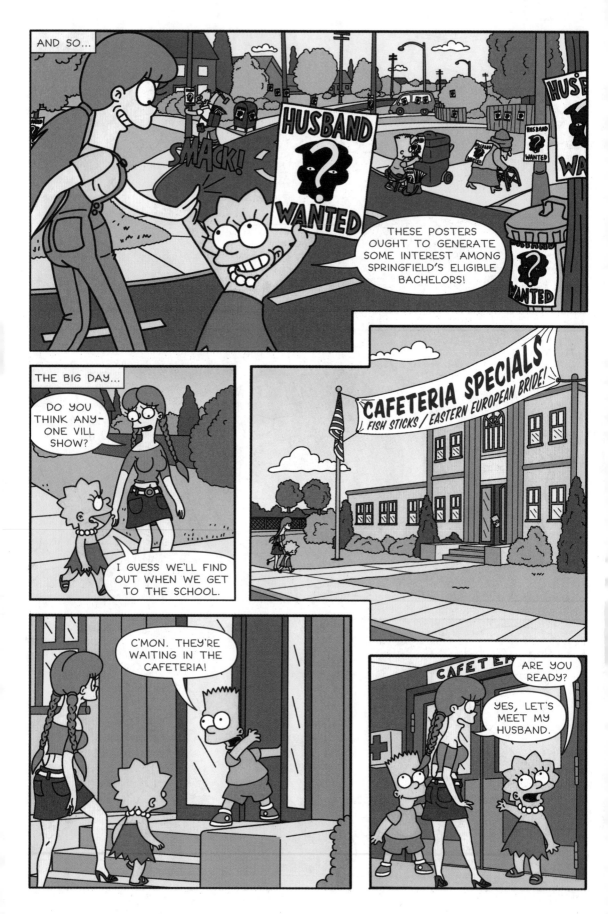

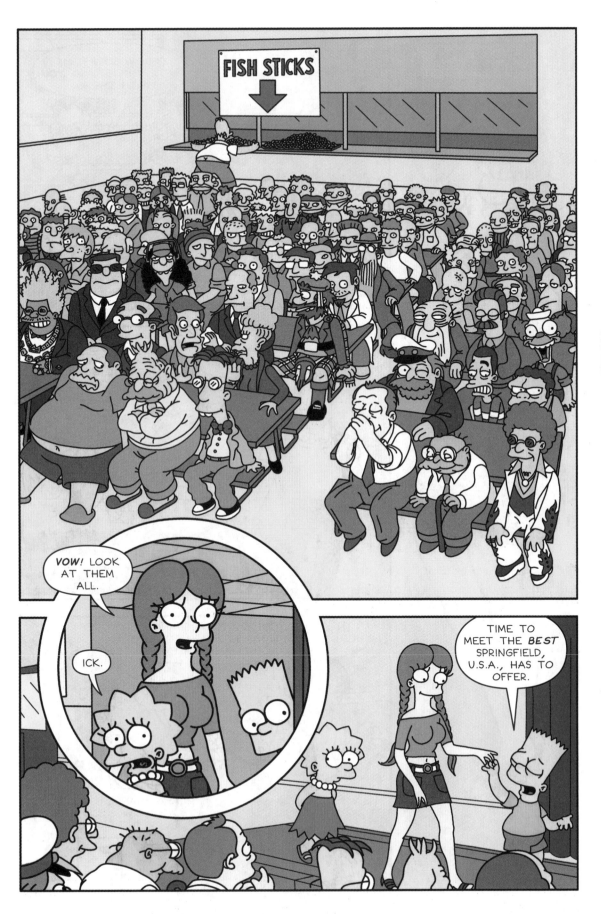

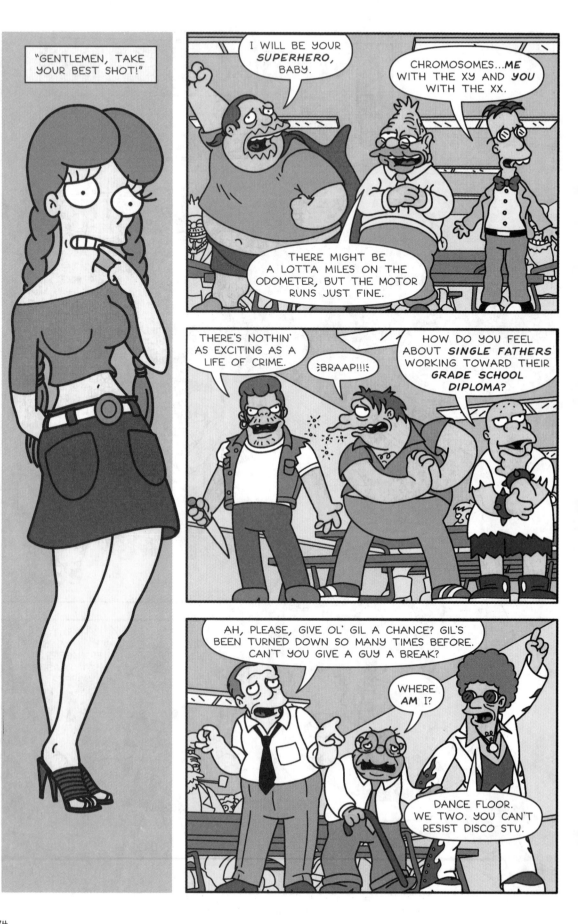

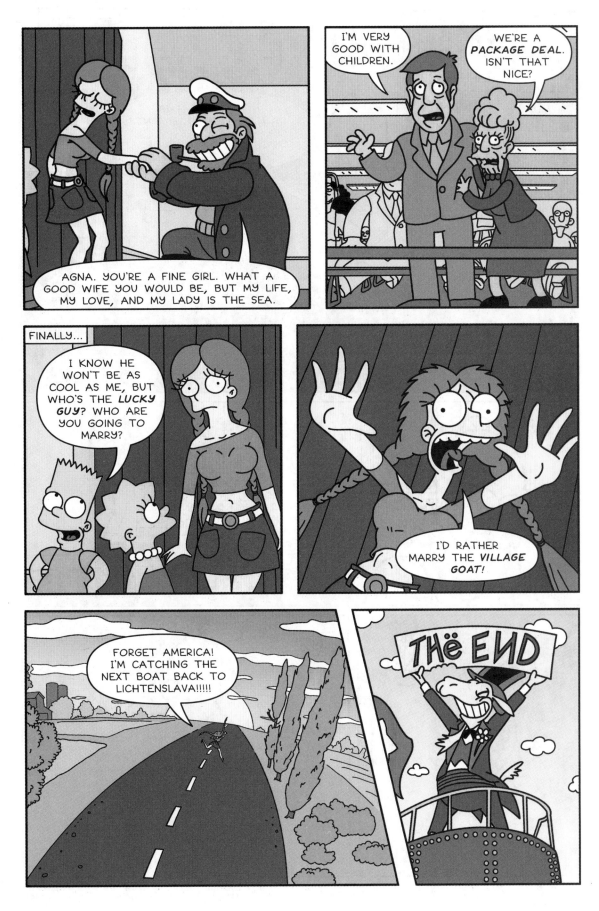

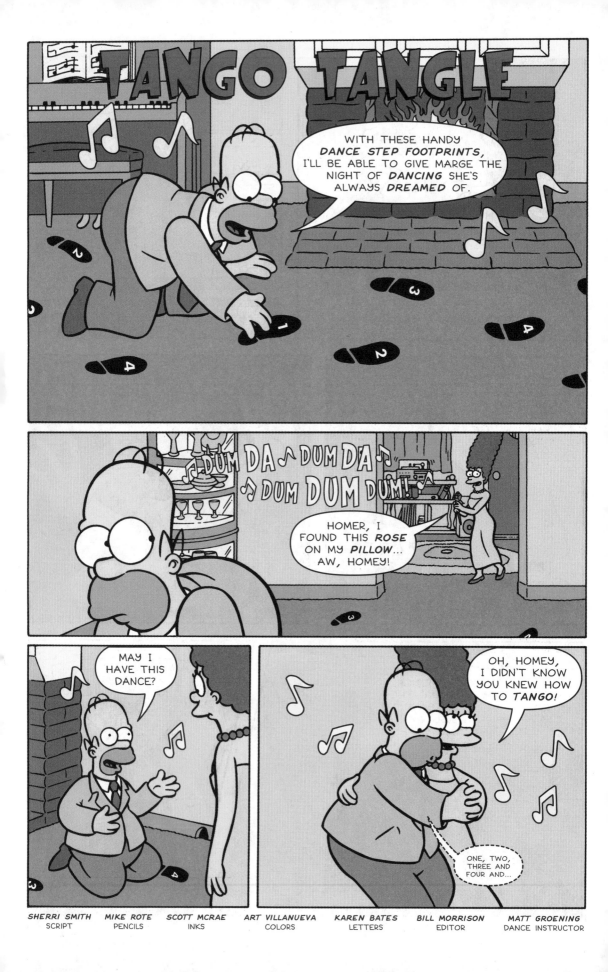

SHERRI SMITH
SCRIPT

MIKE ROTE
PENCILS

SCOTT McRAE
INKS

ART VILLANUEVA
COLORS

KAREN BATES
LETTERS

BILL MORRISON
EDITOR

MATT GROENING
DANCE INSTRUCTOR

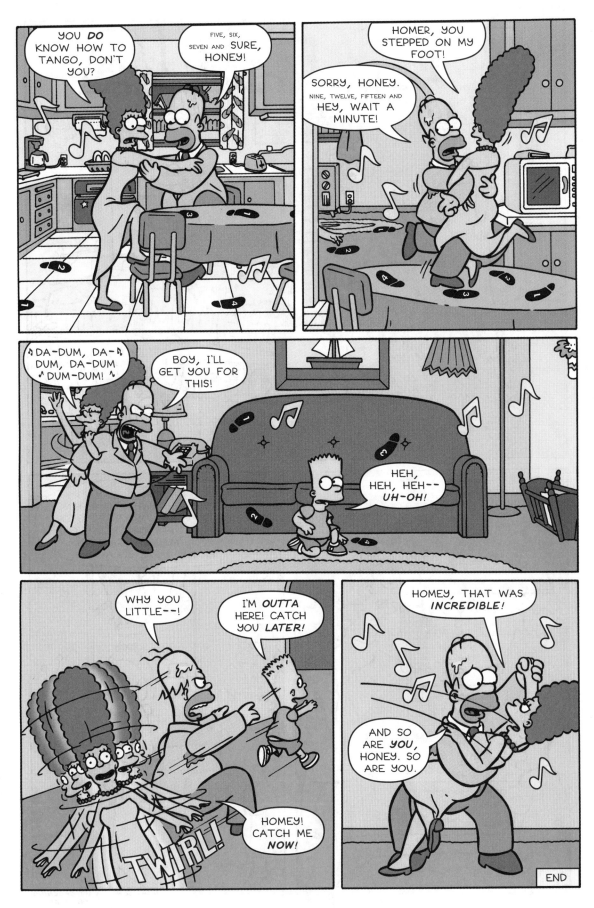

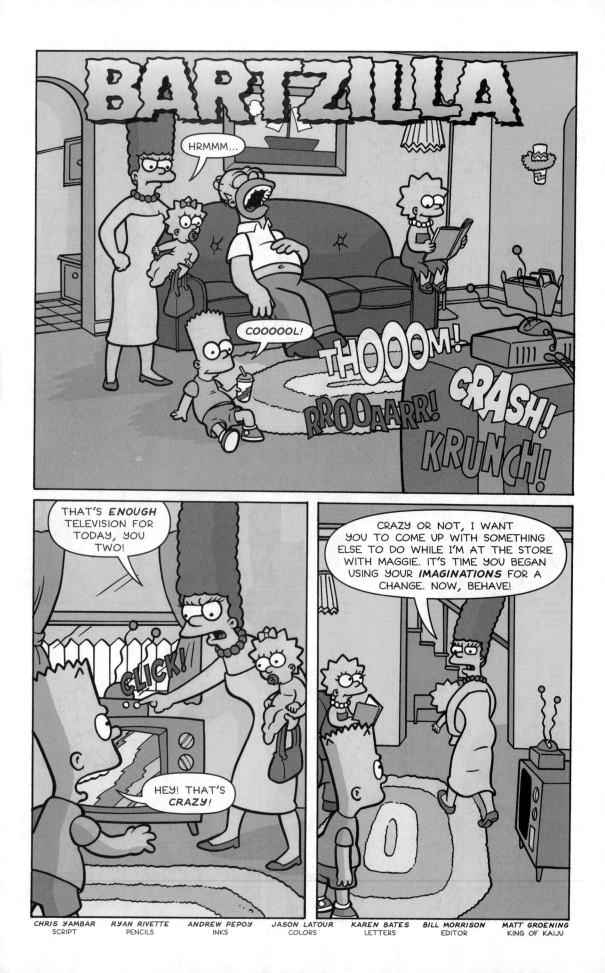

CHRIS YAMBAR
SCRIPT

RYAN RIVETTE
PENCILS

ANDREW PEPOY
INKS

JASON LATOUR
COLORS

KAREN BATES
LETTERS

BILL MORRISON
EDITOR

MATT GROENING
KING OF KAIJU

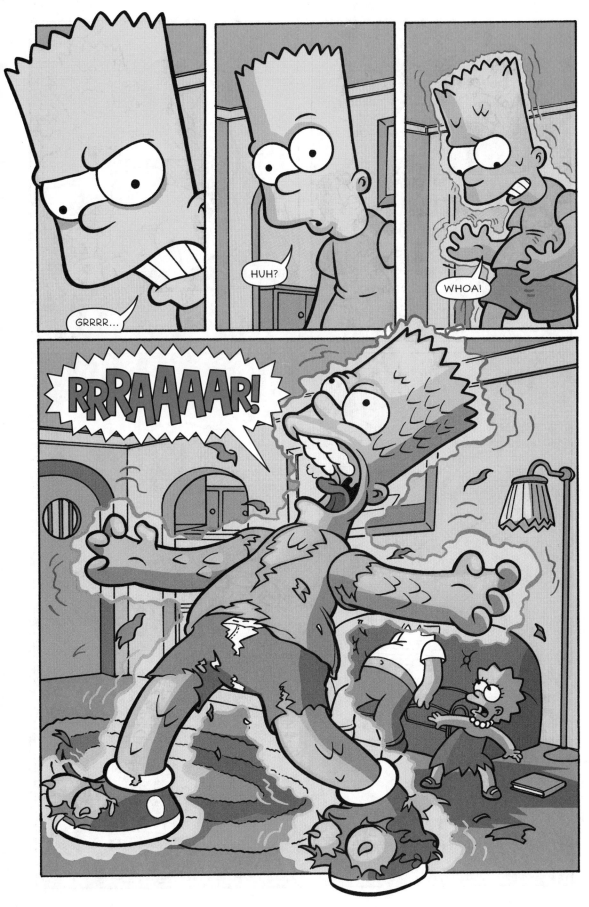

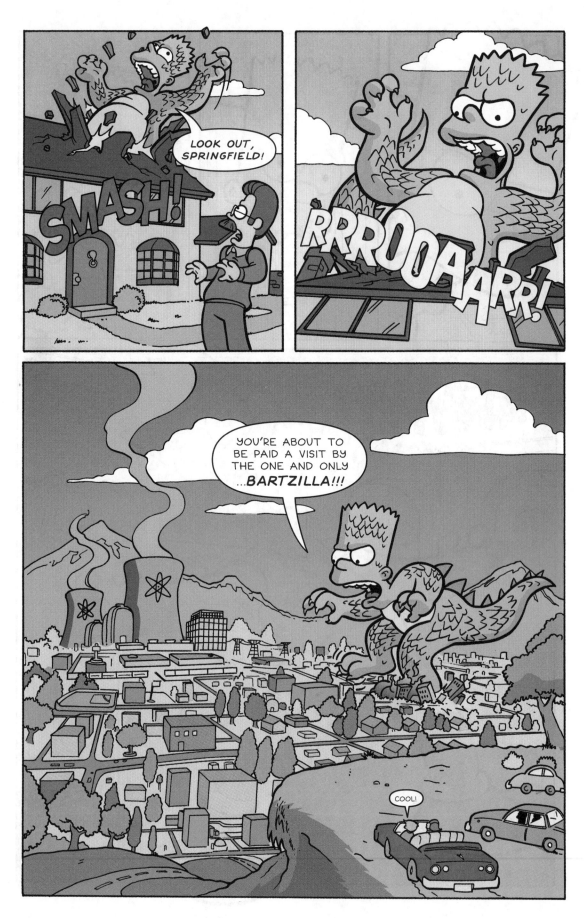

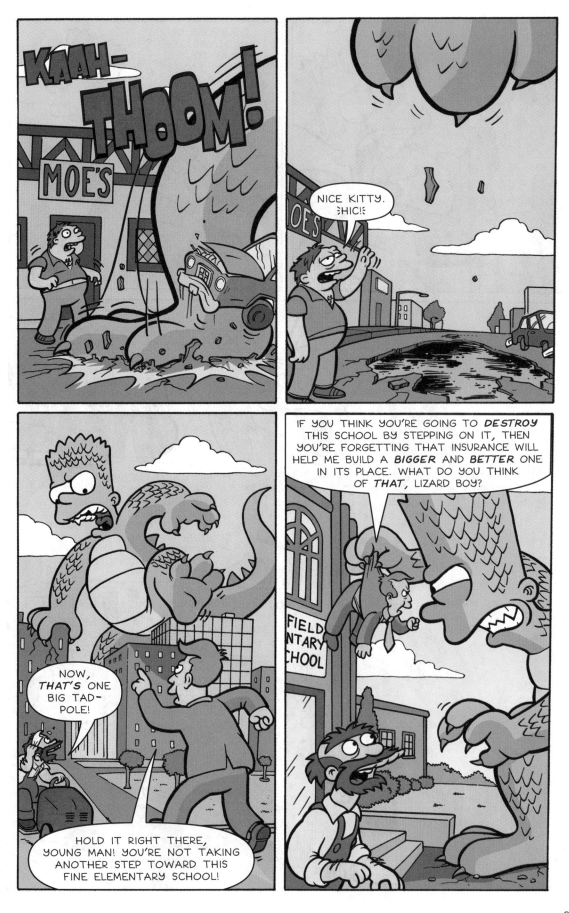

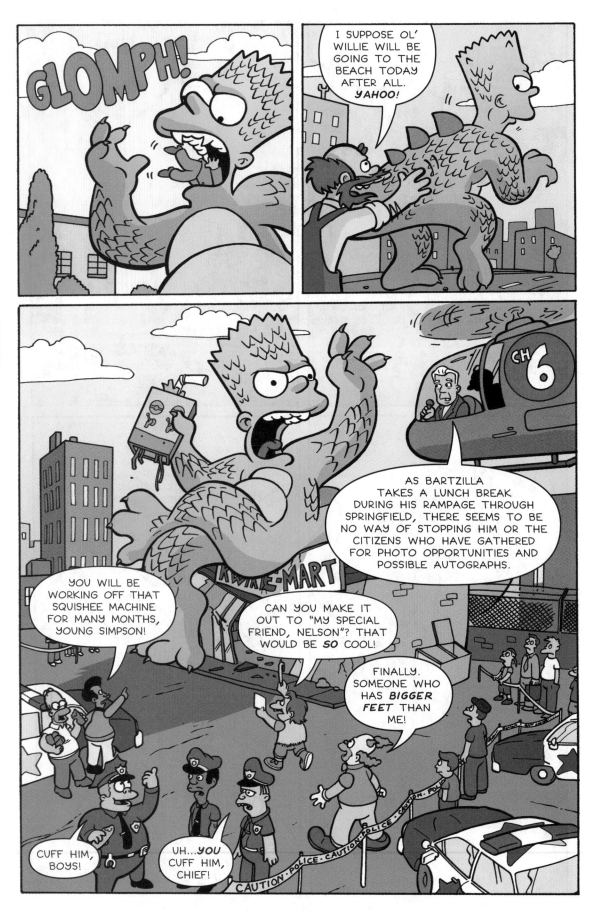

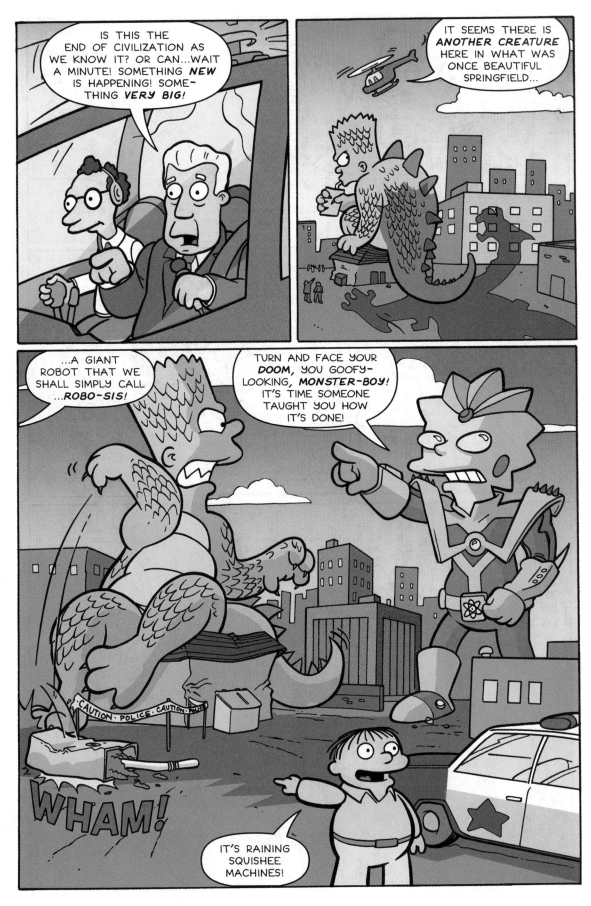

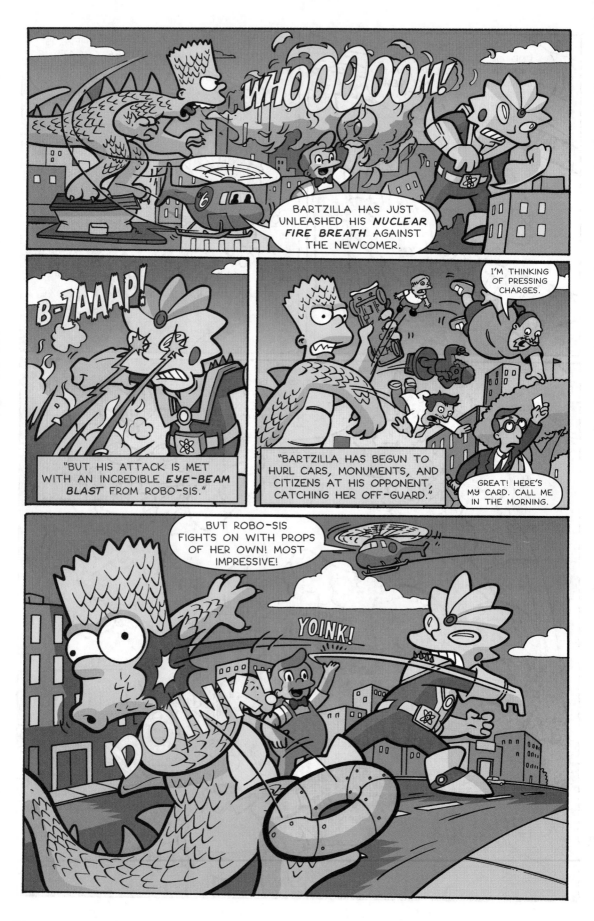

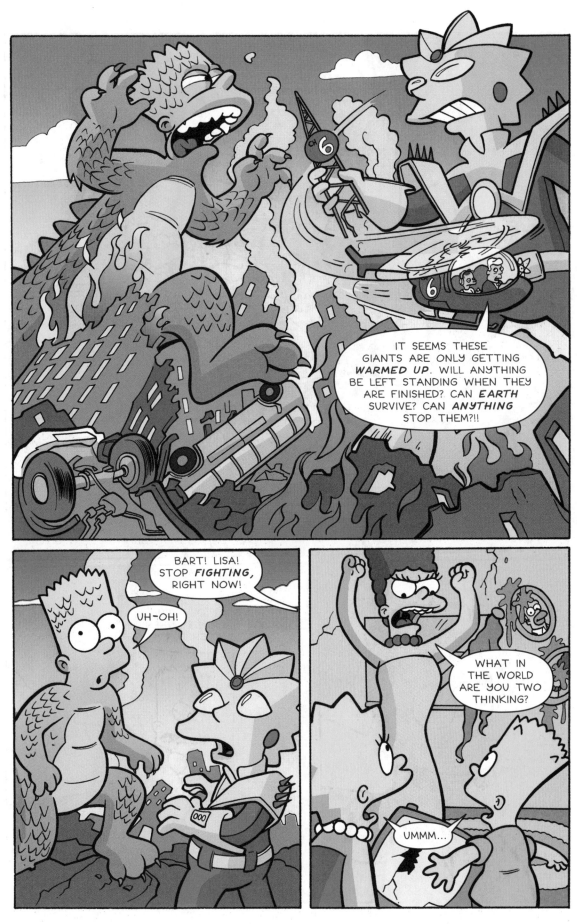

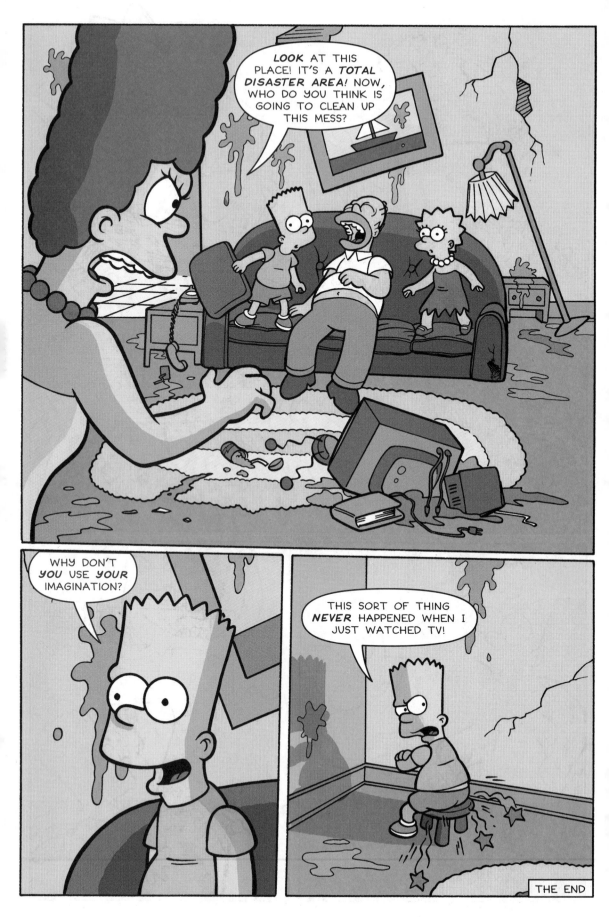

THE END

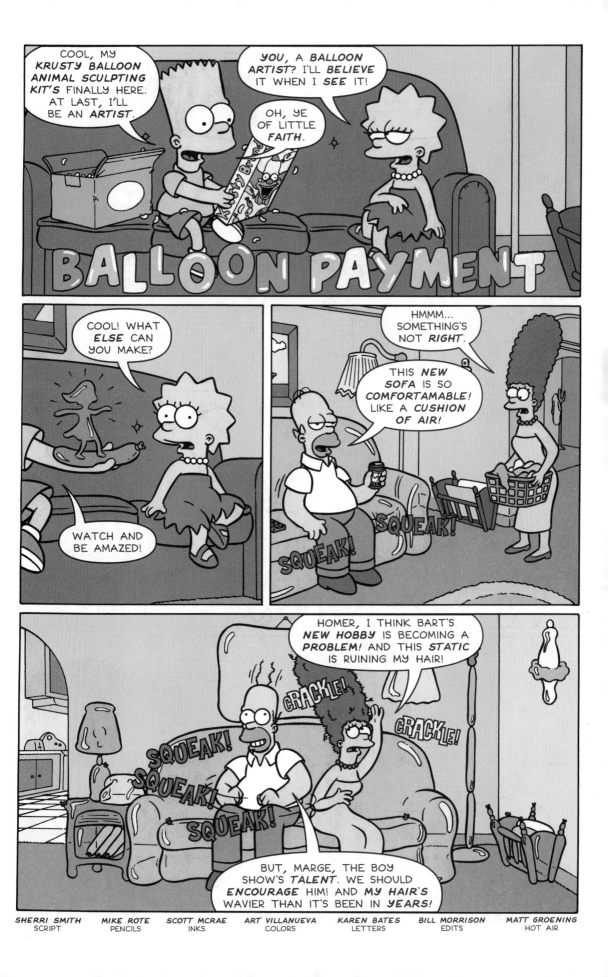

BALLOON PAYMENT

SHERRI SMITH
SCRIPT

MIKE ROTE
PENCILS

SCOTT MCRAE
INKS

ART VILLANUEVA
COLORS

KAREN BATES
LETTERS

BILL MORRISON
EDITS

MATT GROENING
HOT AIR

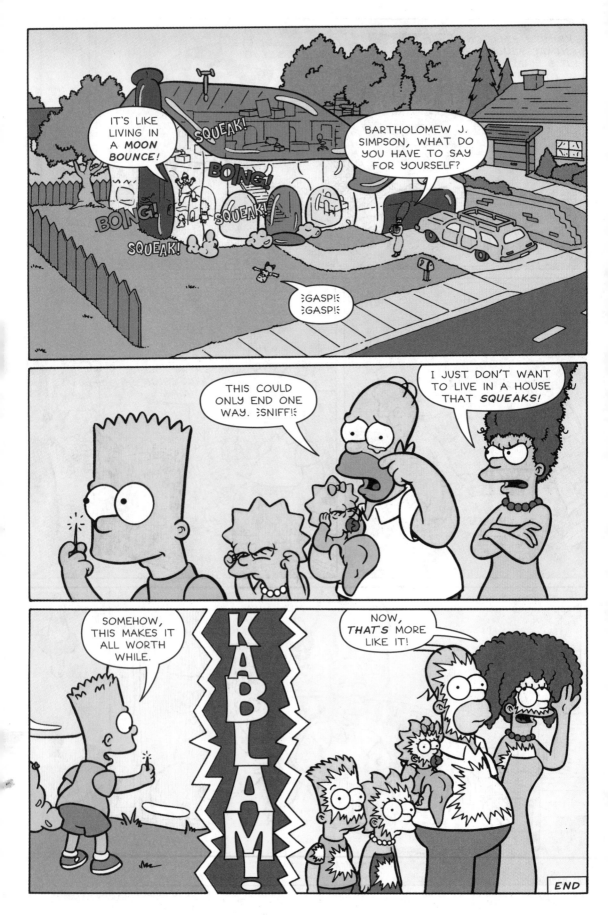

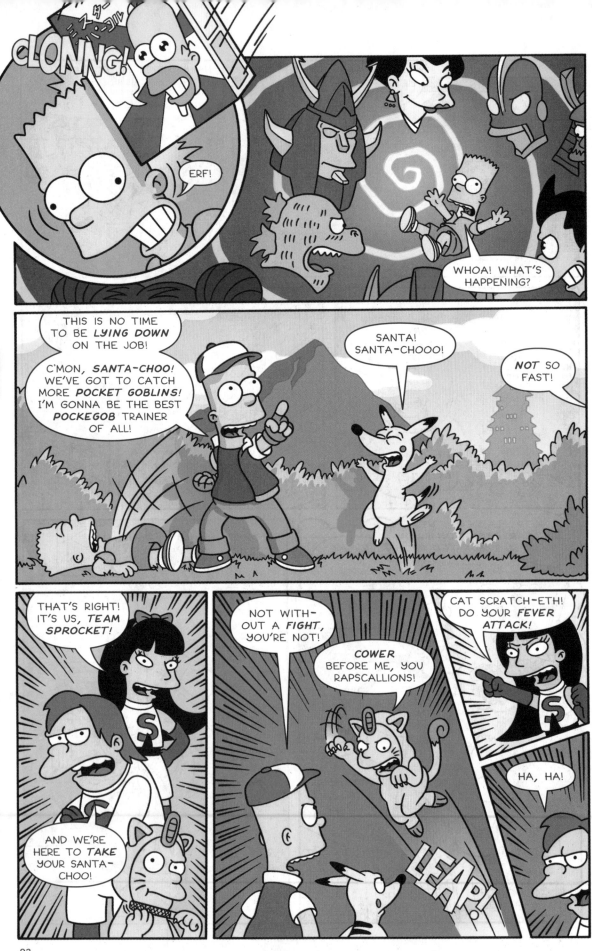

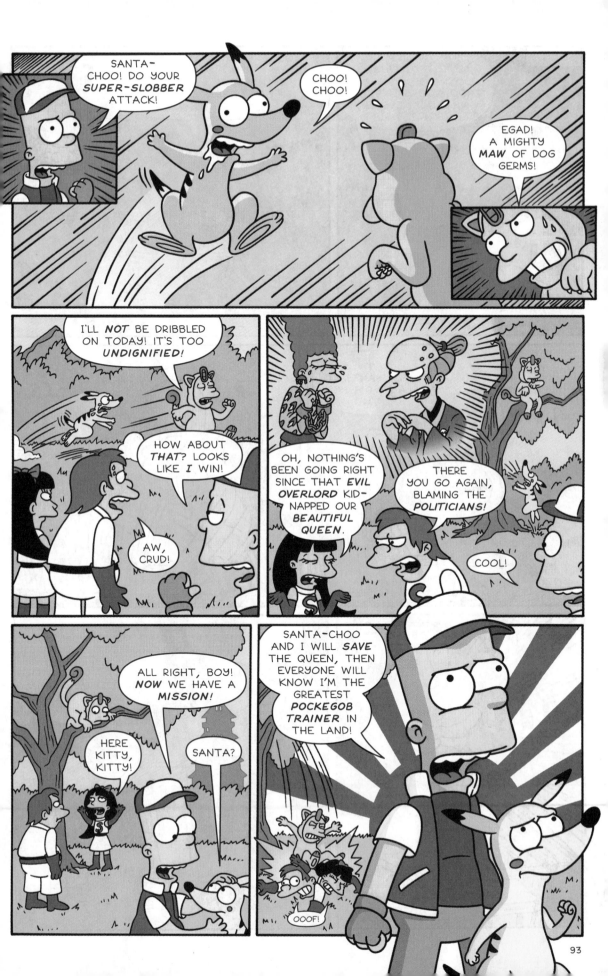

93

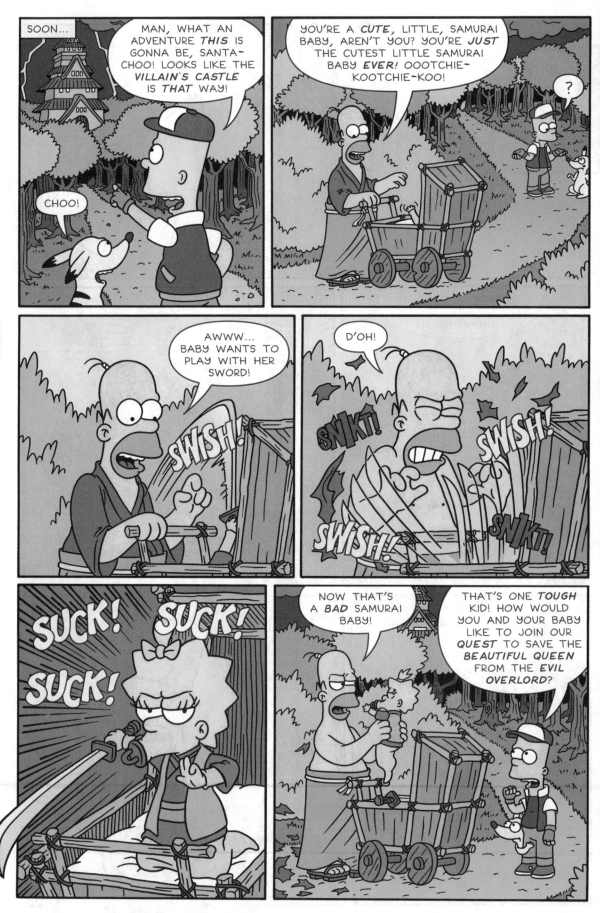

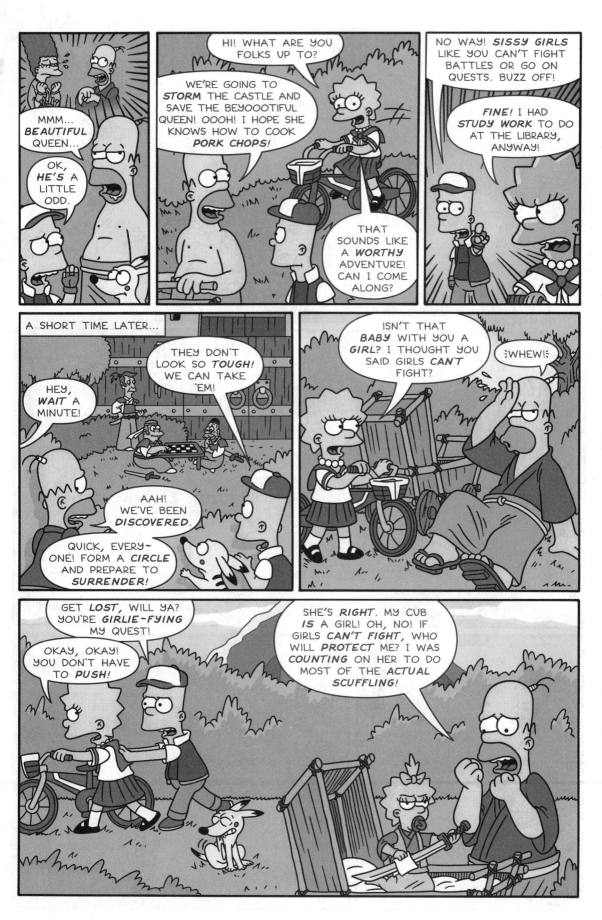

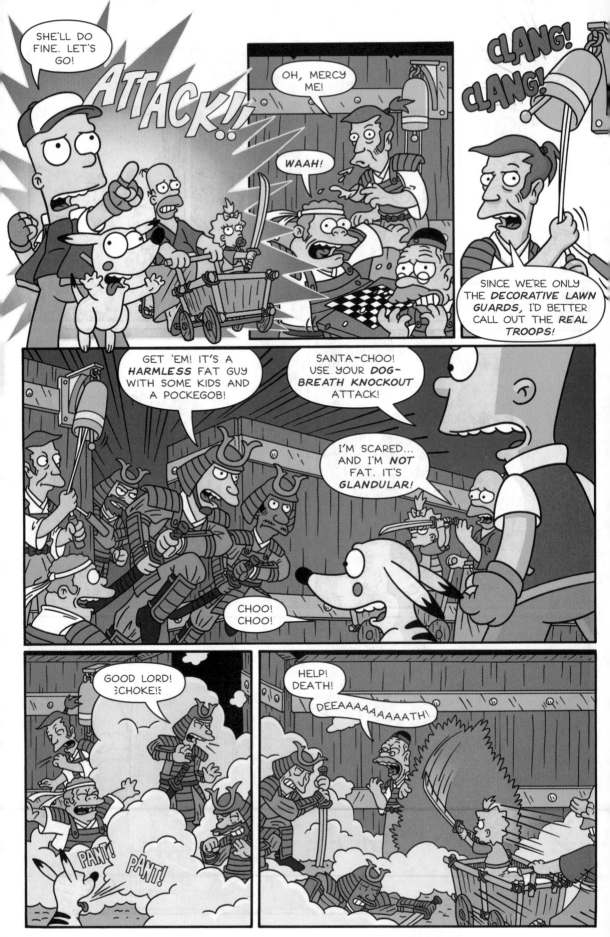

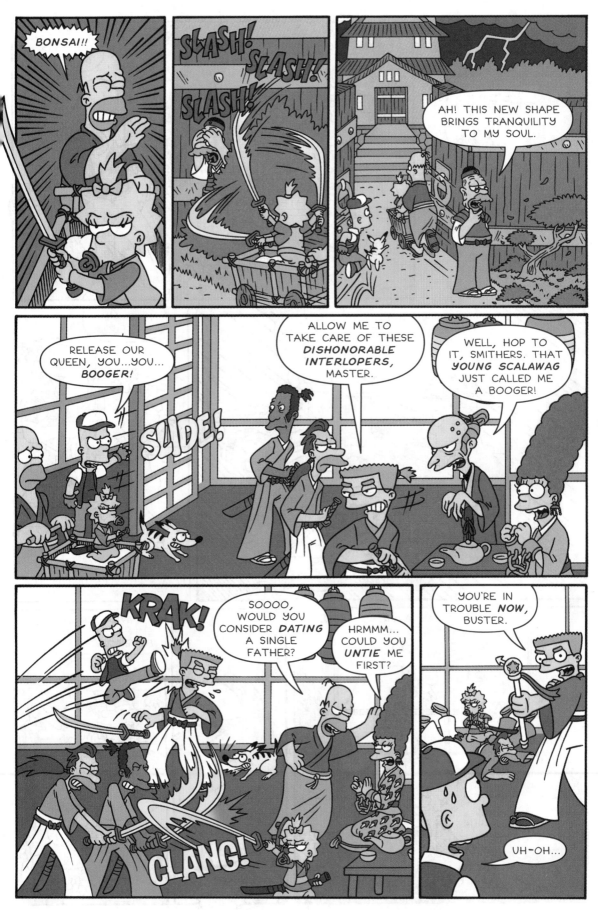

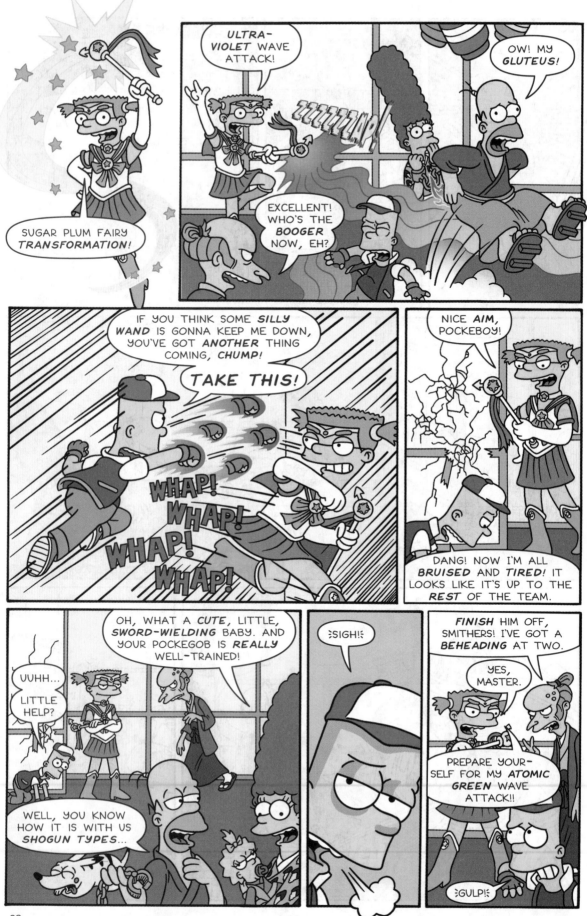

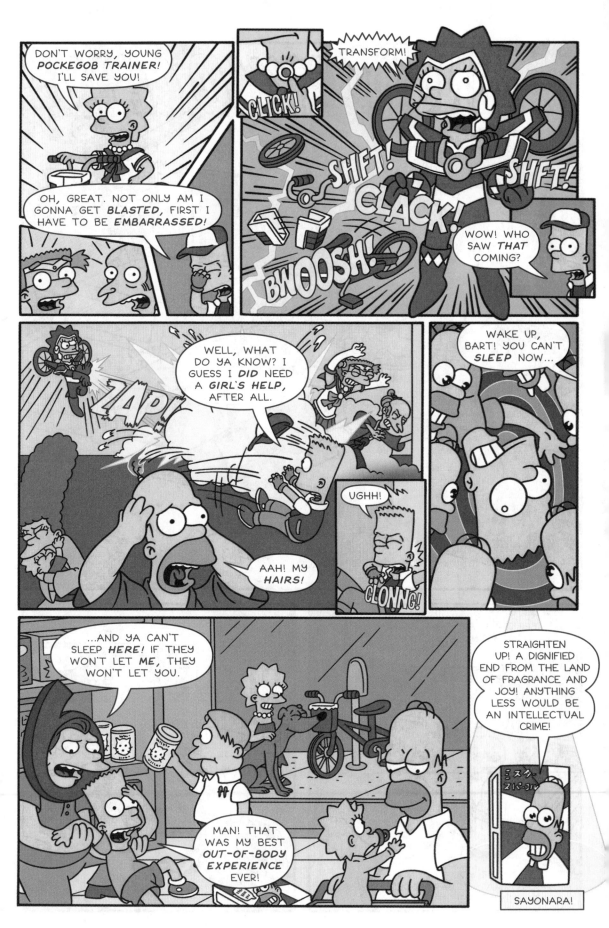

99

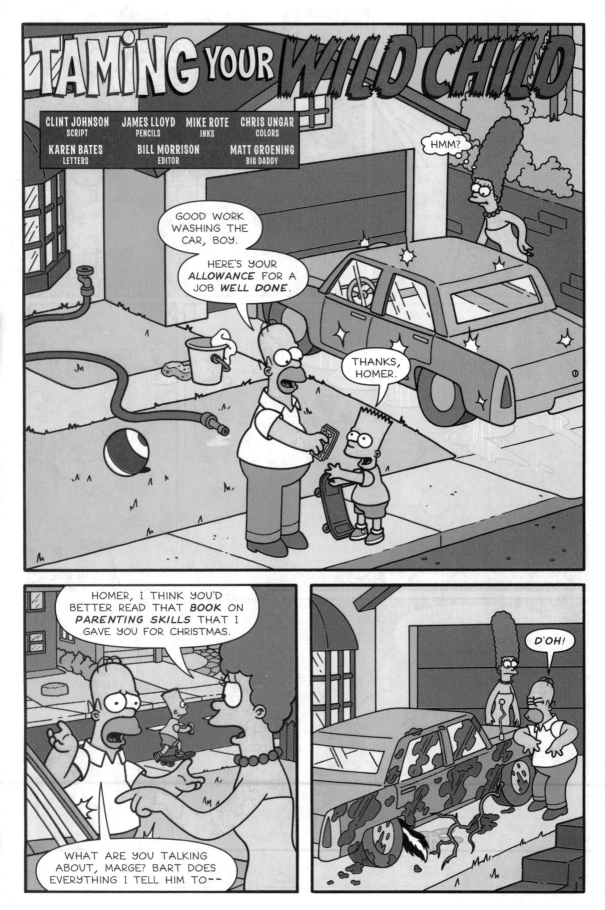

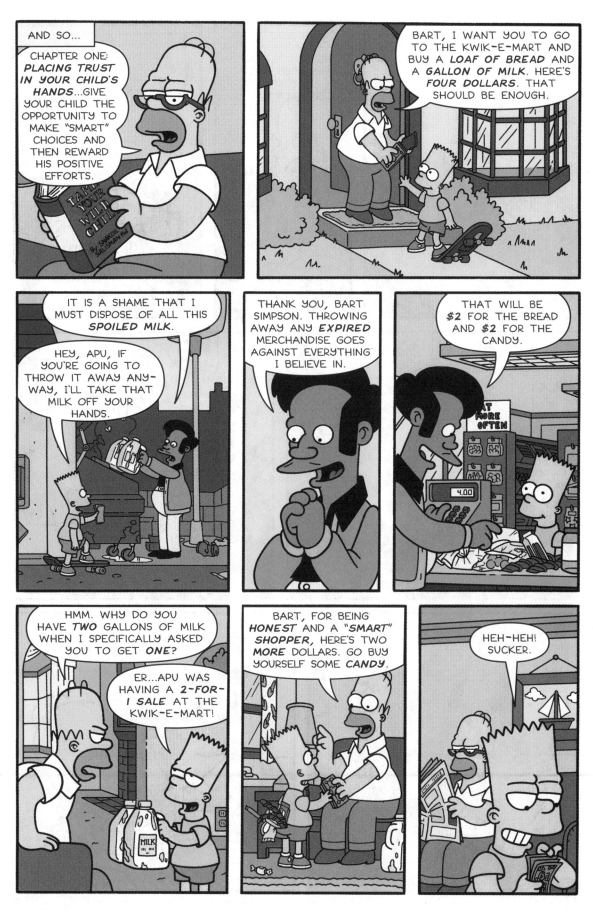

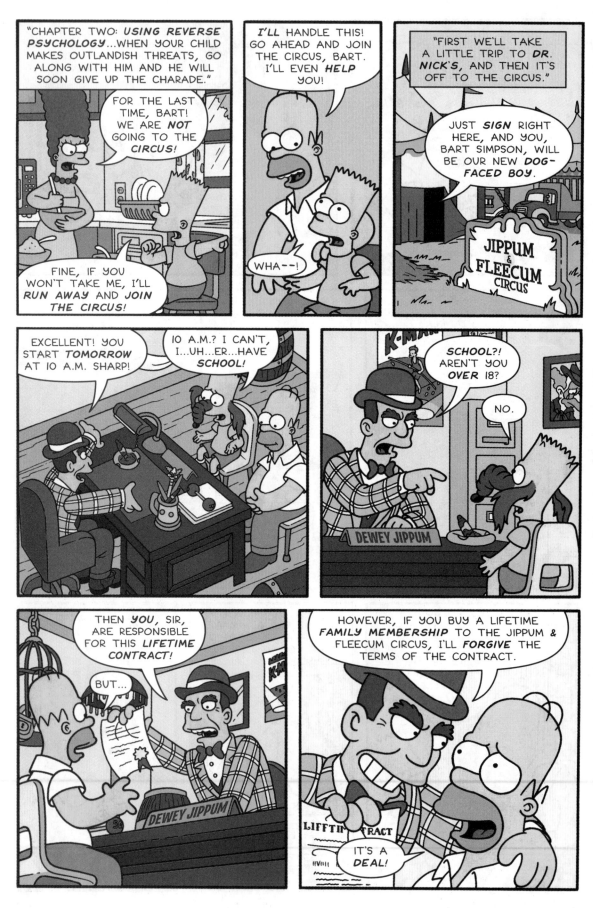

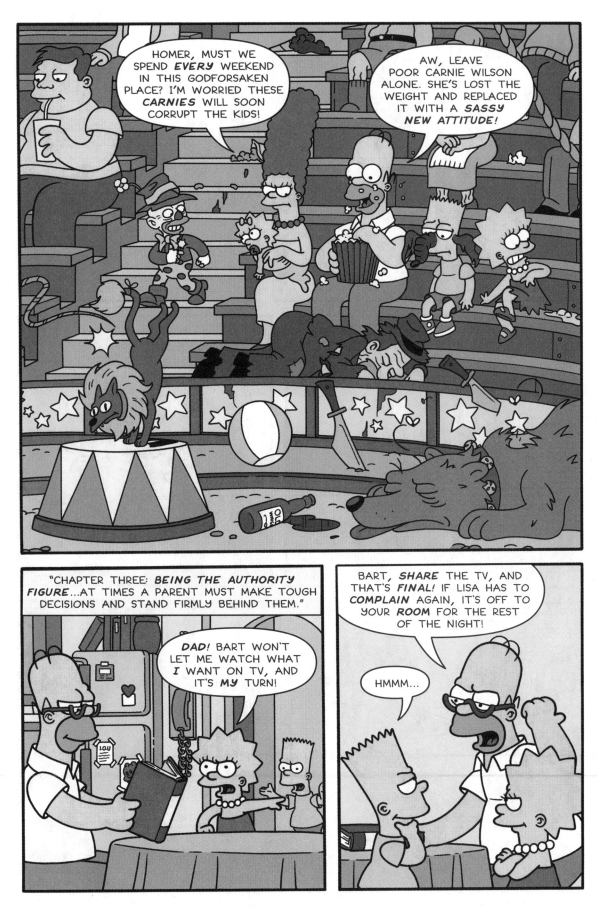

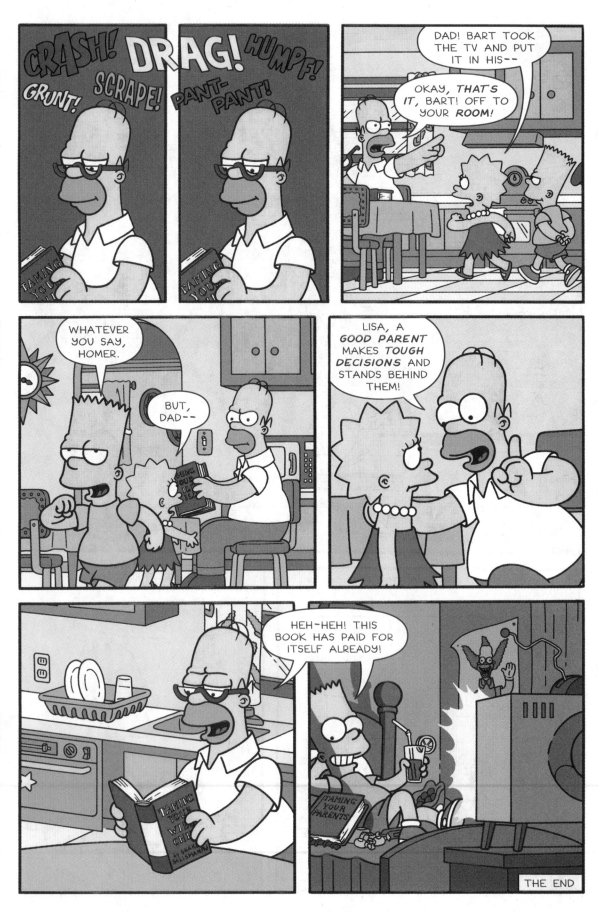

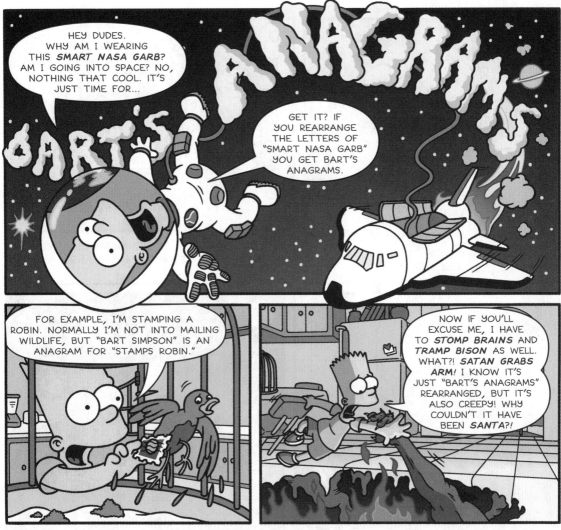

"HERE'S HOW IT WORKS: WITH EACH OF THE PICTURES BELOW, REARRANGE THE LETTERS OF THE PERSON'S NAME TO FIGURE OUT WHAT THEY'RE DOING."

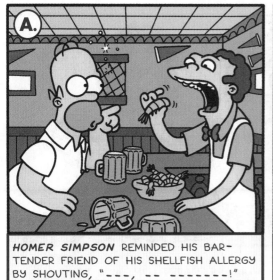

A.

HOMER SIMPSON REMINDED HIS BAR-TENDER FRIEND OF HIS SHELLFISH ALLERGY BY SHOUTING, "___, __ _____!"

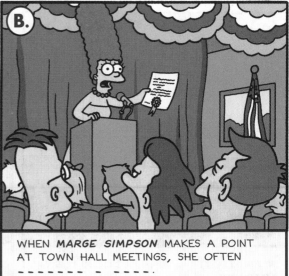

B.

WHEN *MARGE SIMPSON* MAKES A POINT AT TOWN HALL MEETINGS, SHE OFTEN _____ _ _____.

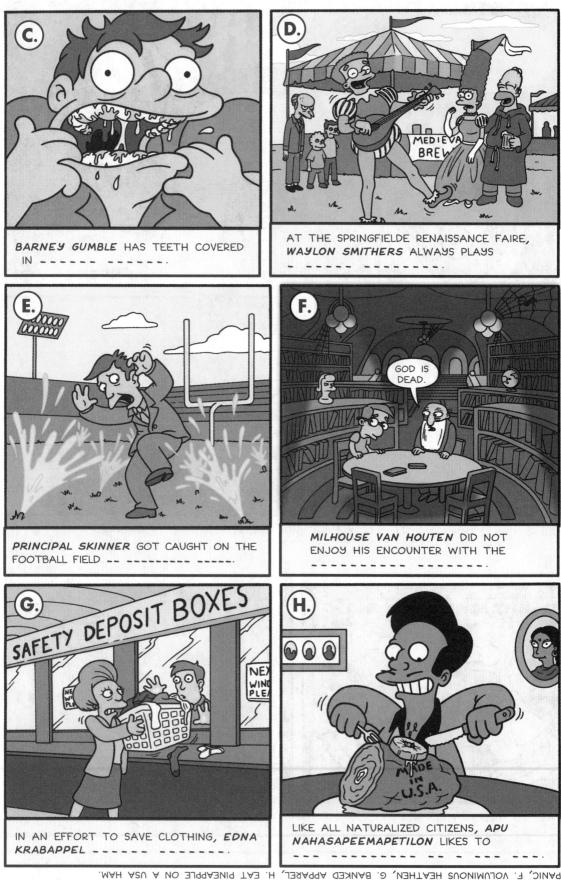

C. BARNEY GUMBLE HAS TEETH COVERED IN - - - - - - - - - - - - - .

D. AT THE SPRINGFIELDE RENAISSANCE FAIRE, WAYLON SMITHERS ALWAYS PLAYS - - - - - - - - - - - - - .

E. PRINCIPAL SKINNER GOT CAUGHT ON THE FOOTBALL FIELD -- - - - - - - - - - - - - - - .

F. GOD IS DEAD. MILHOUSE VAN HOUTEN DID NOT ENJOY HIS ENCOUNTER WITH THE - - - - - - - - - - - - - - - - - .

G. SAFETY DEPOSIT BOXES. IN AN EFFORT TO SAVE CLOTHING, EDNA KRABAPPEL - - - - - - - - - - .

H. LIKE ALL NATURALIZED CITIZENS, APU NAHASAPEEMAPETILON LIKES TO - - - - - - - - - - - - - - - - - - - .

A. MOE, NO SHRIMPS! B. SPRINGS A MEMO, C. GRUBBY ENAMEL, D. A SHOWY MINSTREL, E. IN SPRINKLER PANIC, F. VOLUMINOUS HEATHEN, G. BANKED APPAREL, H. EAT PINEAPPLE ON A USA HAM.

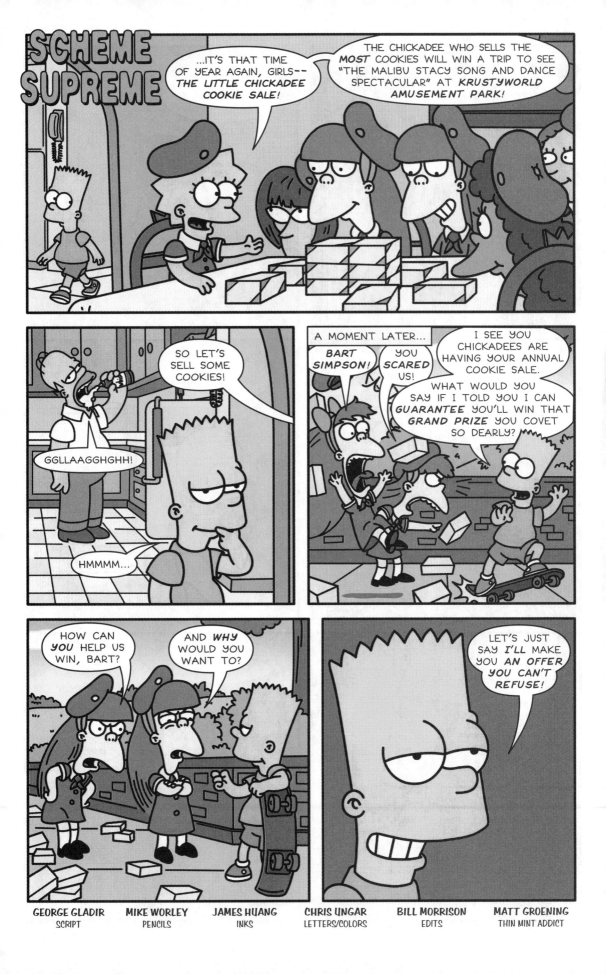

SCHEME SUPREME

...IT'S THAT TIME OF YEAR AGAIN, GIRLS-- *THE LITTLE CHICKADEE COOKIE SALE!*

THE CHICKADEE WHO SELLS THE *MOST* COOKIES WILL WIN A TRIP TO SEE "THE MALIBU STACY SONG AND DANCE SPECTACULAR" AT *KRUSTYWORLD* AMUSEMENT PARK!

SO LET'S SELL SOME COOKIES!

GGLLAAGGHGHH!

HMMMM...

A MOMENT LATER...

BART SIMPSON!

YOU *SCARED* US!

I SEE YOU CHICKADEES ARE HAVING YOUR ANNUAL COOKIE SALE.

WHAT WOULD YOU SAY IF I TOLD YOU I CAN *GUARANTEE* YOU'LL WIN THAT *GRAND PRIZE* YOU COVET SO DEARLY?

HOW CAN *YOU* HELP US WIN, BART?

AND *WHY* WOULD YOU WANT TO?

LET'S JUST SAY *I'LL* MAKE YOU *AN OFFER YOU CAN'T REFUSE!*

GEORGE GLADIR
SCRIPT

MIKE WORLEY
PENCILS

JAMES HUANG
INKS

CHRIS UNGAR
LETTERS/COLORS

BILL MORRISON
EDITS

MATT GROENING
THIN MINT ADDICT

BART FINK AND THE MIGHTY MISSISSIP

THE *RIVER-BOAT!* SHE'S A-COMIN'!

JESSE MCCANN & ABBY DENSON
SCRIPT

PHIL ORTIZ
PENCILS

PATRICK OWSLEY
INKS

ART VILLANUEVA
COLORS

KAREN BATES
LETTERS

BILL MORRISON
EDITOR

MATT GROENING
STEAMBOAT CAPTAIN

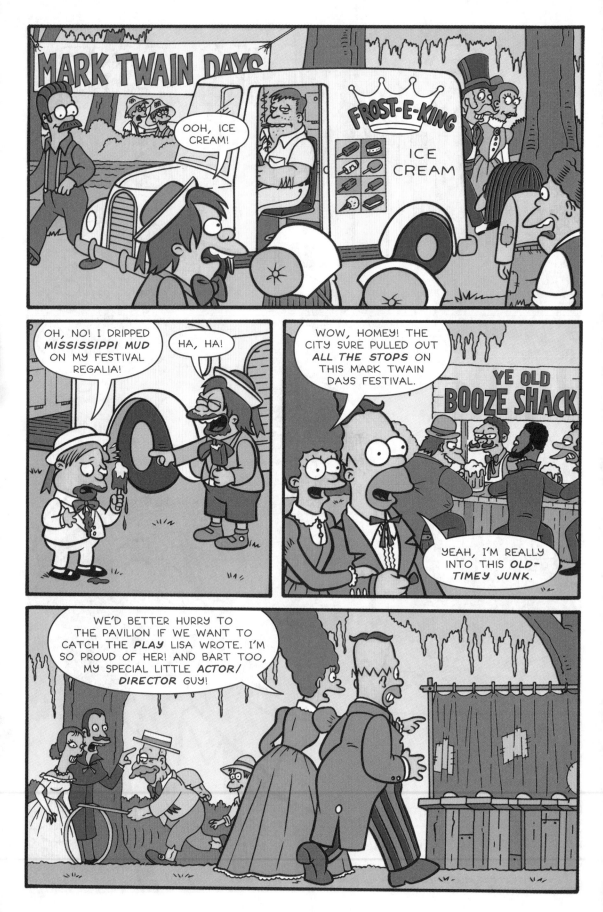

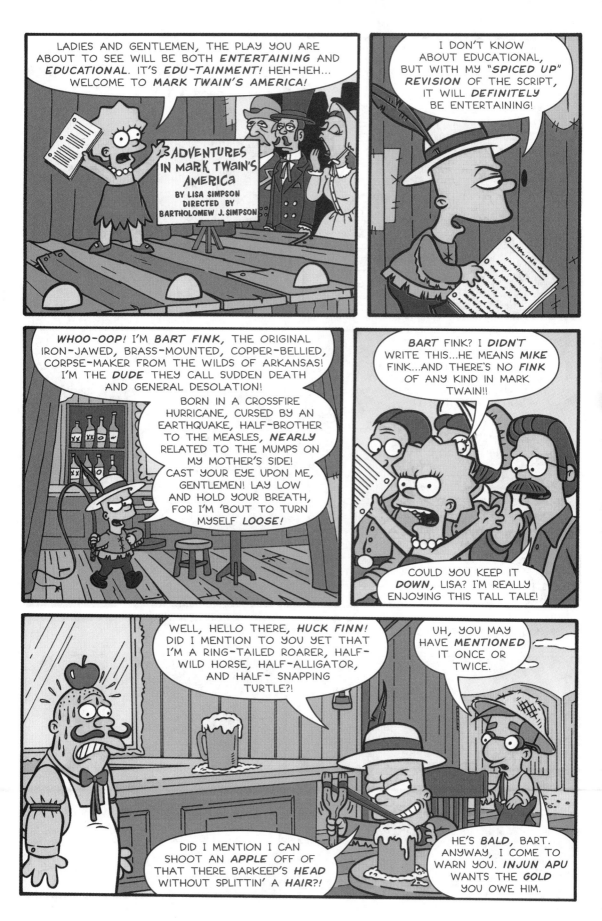

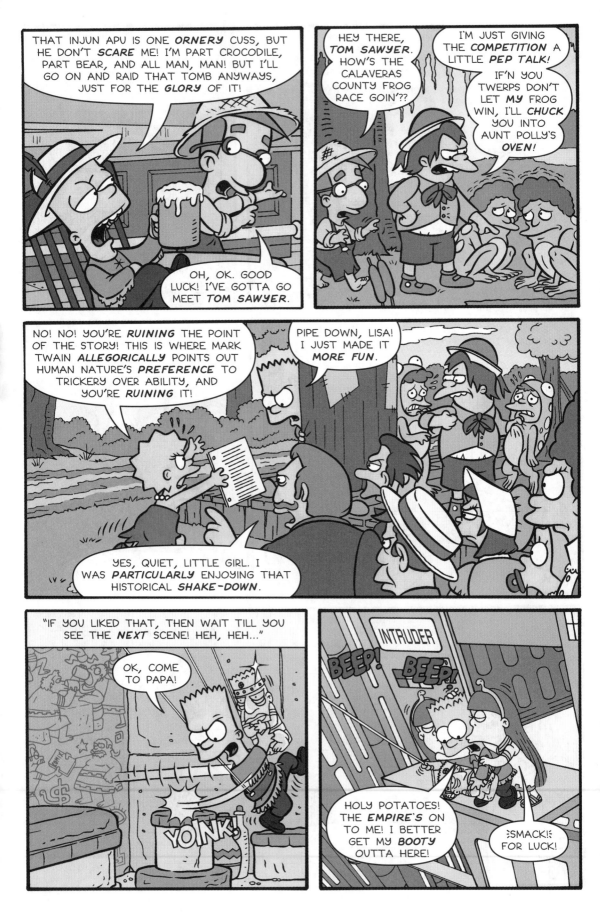

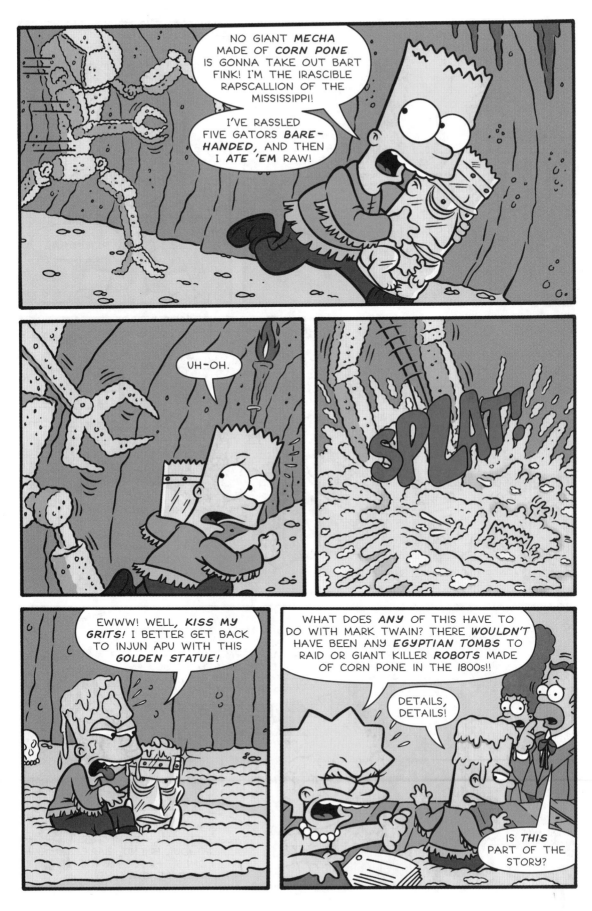

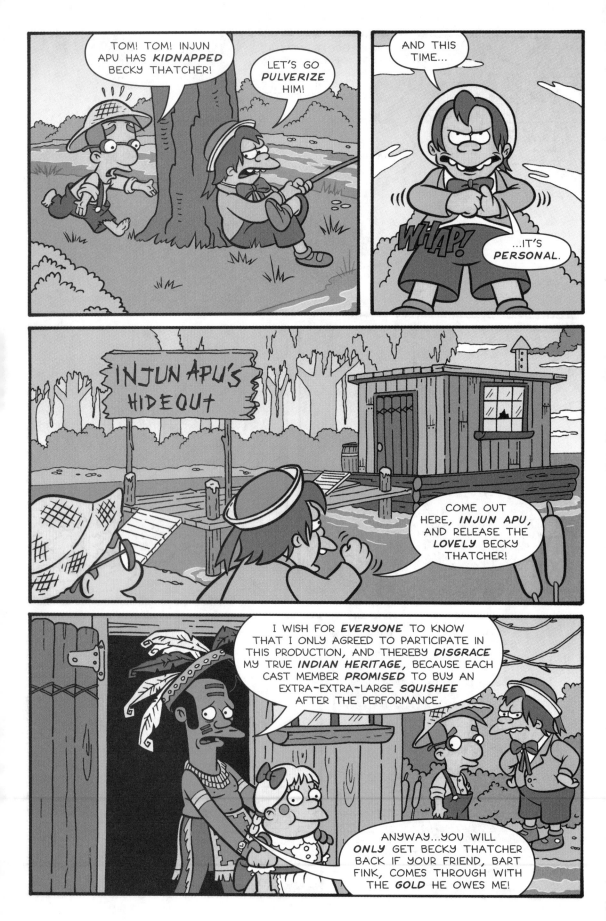

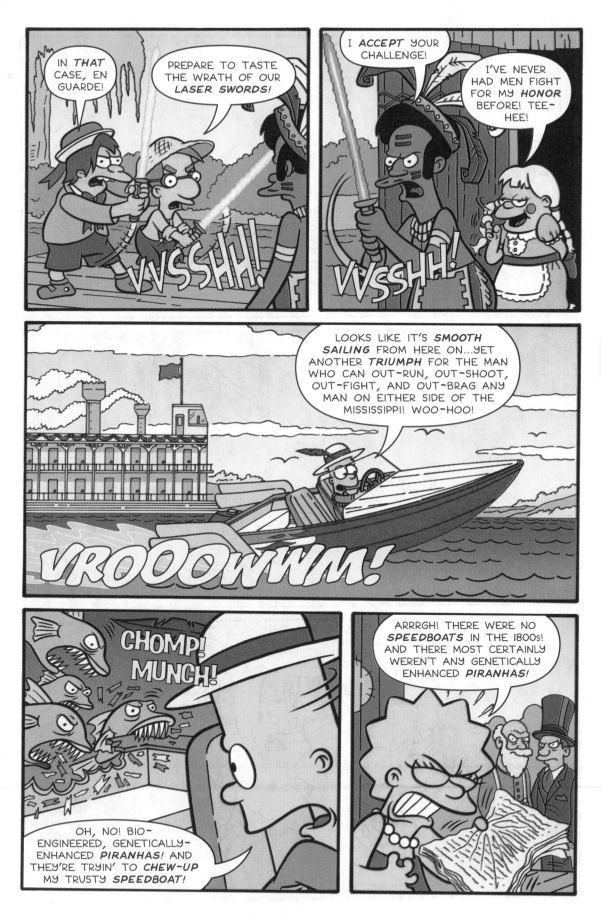

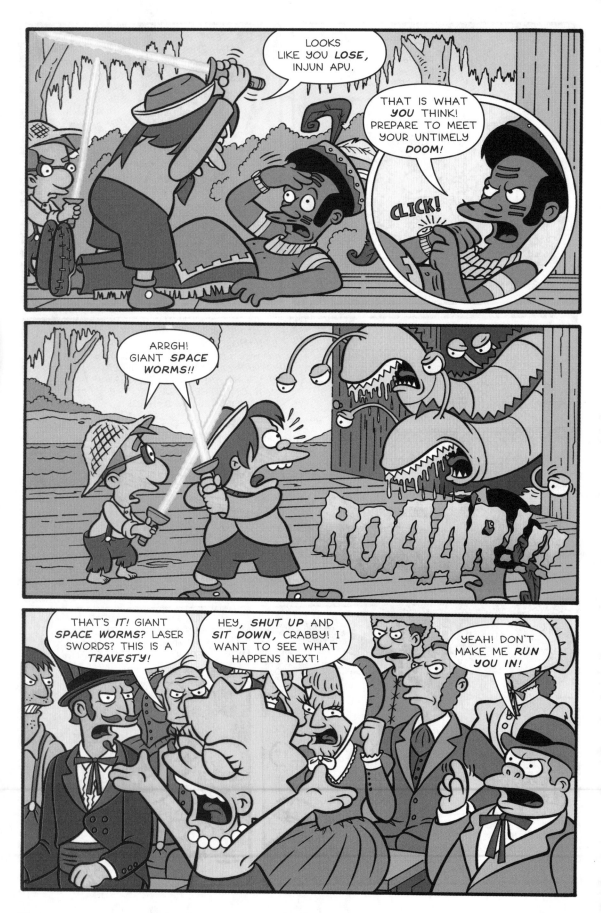

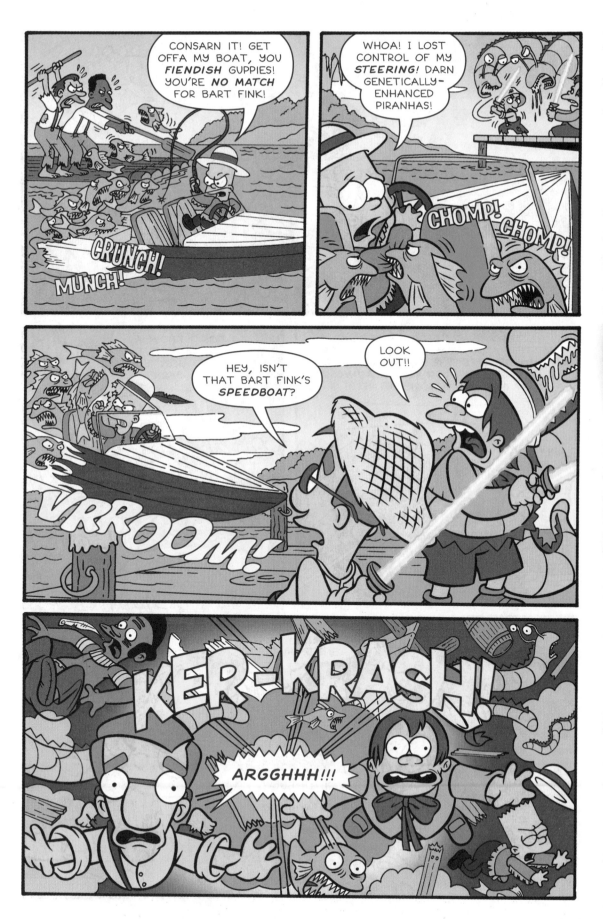

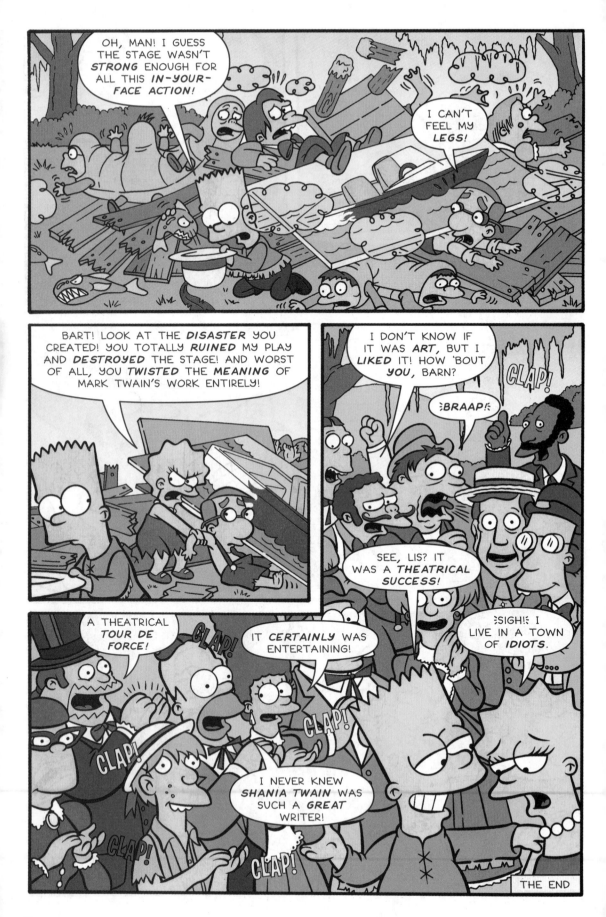